D1408682

COLLECTING
ART DECO

Kevin McConnell

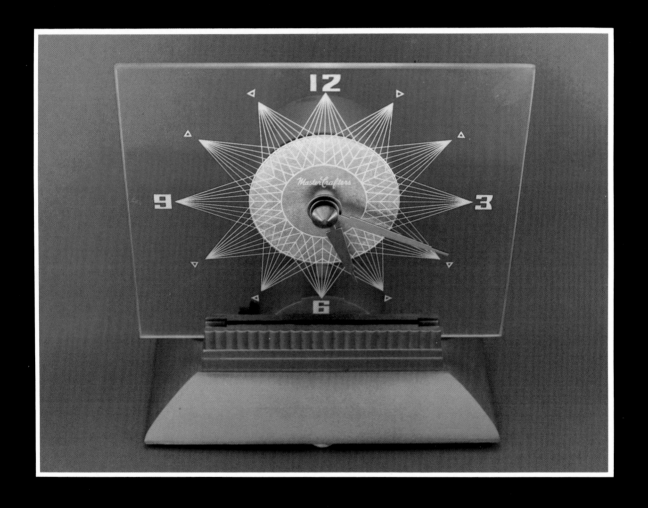

1469 Morstein Road, West Chester, Pennsylvania 19380

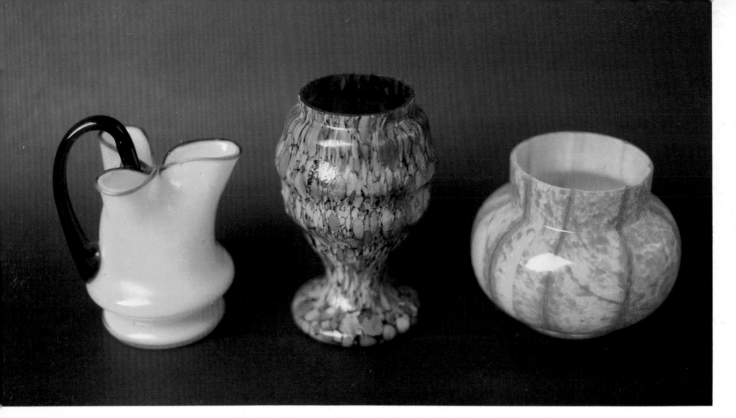

A colorful assemblage of Czechoslovakian glassware,
ranging from 3¾" to 5¼" in height.

Published by Schiffer Publishing, Ltd.
1469 Morstein Road
West Chester, Pennsylvania 19380
Please write for a free catalog.
This book may be purchased from the publisher.
Please include $2.00 postage.
Try your bookstore first.

Copyright © 1990 by Kevin McConnell.
Library of Congress Catalog Number: 90-62902.

Printed in the United States of America.
ISBN: 0-88740-279-8

Front cover photo:
A 12" high chalkware figurine incorporating classic Art
Deco motifs: a nude woman and geometric forms.

Title page photo:
An Art Deco glass and metal electric clock made by
Master Crafters, 9" high, 8½" wide.

Contents

Fiesta Ware, first made in 1936 by the Homer Laughlin China Company, remains a perennial favorite with Art Deco collectors.

Acknowledgements

As odd as it may seem and sound, Art Deco collecting is alive and very well in the North Texas area. But it's not so odd when one learns that this modernistic style profoundly prevailed here during the 1920s and the 1930s.

Indeed, it would be difficult to imagine better examples of Art Deco architecture/design than the Fair Park complex in Dallas or the Will Rogers complex in Fort Worth. With such an influential, omnipresent backdrop, it's little wonder that there are so many devoted collectors in this region.

This is a fact for which I am most grateful. Having driven thousands and thousands of miles to complete my previous reference books, I can assure you that it was a real novelty to have everything I needed to photograph within a sixty-mile radius.

Consequently, I would like to thank the following folks and firms for their help, encouragement, suggestions, and patience in putting this book together:

Paul Isbell, Don Watson, Donna Godwin, Lewisville Antique Mall, Hazel Ranck, Bill Mitchell, Burleson Antique Mall, Bob and Georgia Caraway, Patrick Rankin, Joseph Nye, Les and Sue Thompson, John Bennett, Mike Pennington, Azle Antique Mall, Mr. and Mrs. C.H. McConnell, D. Brett Benson, Jim and Gloria Jordan, John Perkins, Bluebird's Nest Antiques, Matthew and Beverly Robb, Robert Wyman Newton, Robert L. Gordon, Cleburne Antique Mall, Karen Silvermintz, Trudy Miller, Barbara Adelglass, Joan Amberg, The Antique Sampler, and Antique Country of Keller.

I am especially indebted to Kenn Darity and Ed Murchison of The Essex Decollectibles, Patrick J. Ross of Hillis Ross Antiques, Mark D. Stallons and Chris A. Patton of Anything Goes Antiques, and David Spillyards and Beverly Searcy for permitting me to photograph their impressive Art Deco assemblages.

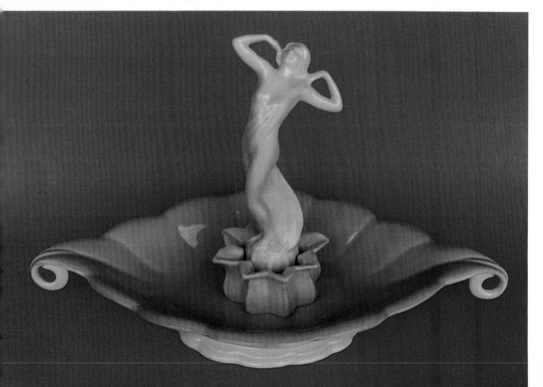

A graceful and delicate Cowan figural flower frog with matching console bowl, 12" overall height, 16" long.

Introduction

If you've purchased this book, I'd like to thank you for doing so. As we all know, there are already quite a few Art Deco books on the market, and mine makes one more.

However, I truly believe that each author has their own unique point of view and addresses the chosen subject matter differently. After perusing the currently available Art Deco books, I chose to format mine with approximately 400 high-quality color photos, encompassing a wide array of strongly designed objects.

No subject matter is more deserving of the full color treatment than Art Deco, and it is my hope that you find these photographs to be both interesting and informative. It's always been my philosophy that good photos often succeed in educating where lots of heavy text fails.

The text that I *have* included here has been presented in a streamlined, concise, and readable manner in an attempt to provide basic and essential facts.

Beyond all of the above, I decided to do this book for the simplest of reasons: Art Deco is fun, it's largely available and affordable, and I've been an avid collector of it for years.

While it's true that you can pay as much as you want for fine examples of Art Deco, the vast majority of it is accessible to the average person. Most of the items pictured herein fall into the latter category.

Collect it and enjoy.

Kevin McConnell
Denton, Texas

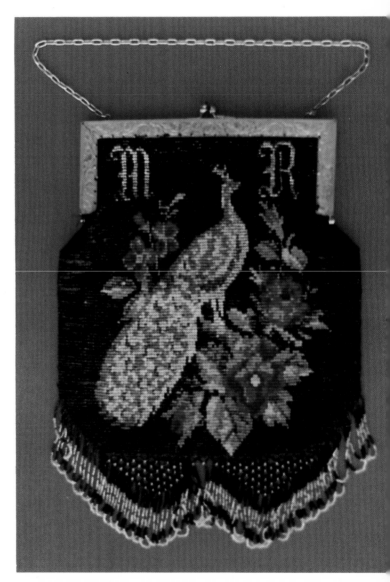

Large beaded purse with conventionalized peacock and floral designs with gilt clasp and chain, overall length is 17".

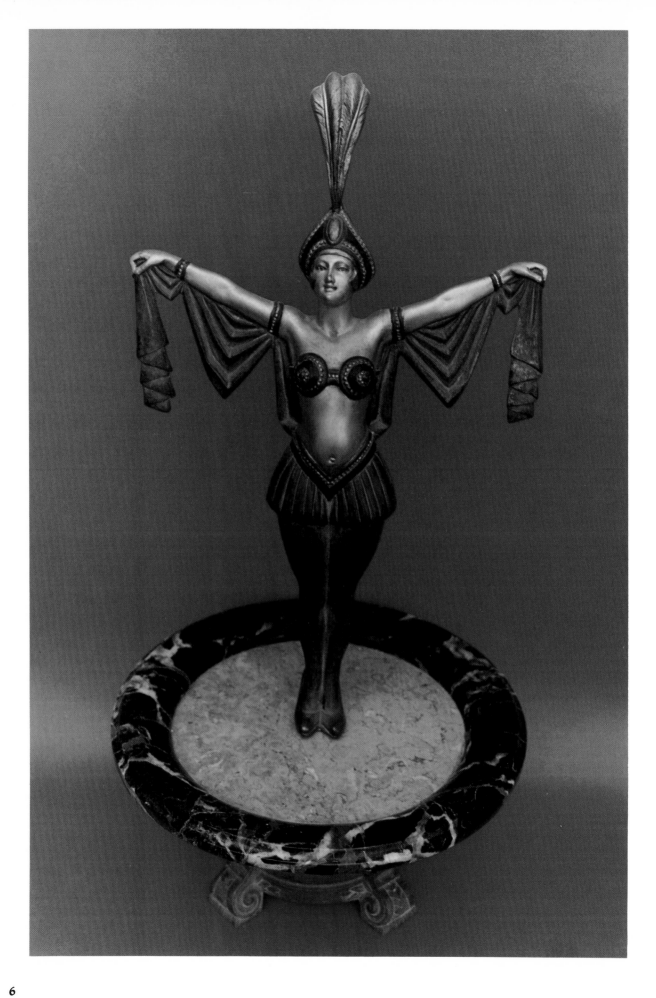

Art Deco Origins and Influences

As is so often the case, pinning down exactly when and where the Art Deco era began is easier said than done. However, there are many experts who feel that the threshold of the period was around 1900 and specifically dated to the founding of the Societe des Artistes Decorateurs or Society of Decorators and Artists of France.

Developing from that society was a new design style that has come to be known as Art Deco, a style that incorporated such wide-ranging themes and elements as contrasting colors, geometrics, stark and streamlined interpretations, nude and seminude figures, visions of the future, representations of speed and motion, and ancient Egyptian motifs.

Art Deco was, in part, a reaction against and an eventual ultra-refinement of the florid Art Nouveau style popular around the turn-of-the-century. Basic themes, the female form for example, were appropriated and reinterpreted accordingly.

Additionally, Art Deco was a reflection of the tumultuous changes and discoveries that were taking place: wireless communication, the advent of the automobile, transcontinental airplane flights, the widespread use of electricity, the discovery of King Tutankhamen's tomb, and so much more.

These radical changes in communication, transportation, and technology resulted in equally radical changes in lifestyles. This rush toward the future can be seen in the material

Opposite page:
This French figural centerpiece incorporates many of the classic Art Deco themes and designs. It is made from a combination of enameled spelter and polished marble and measures 19¼" high and 10" in diameter.

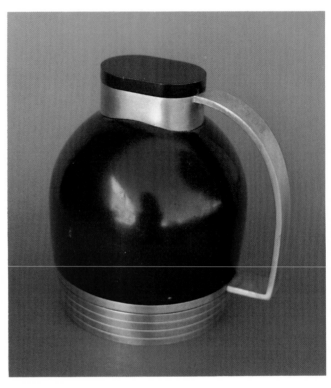

A 7¾" high enameled aluminum thermos of stark industrial design by Dreyfuss.

culture of the 1920s and 1930s, most of which mirrors the new age.

Although it is a point of some controversy, there are many who contend that the Art Deco era culminated in 1925. It was during this year that L'Exposition International des Arts Decoratifs et Industrels Modernes took place in Paris, France. This prestigious event featured contemporary and futuristic visions of functional as well as decorative objects by artists and designers from Austria, Greece, Spain, Monaco, France, Czechoslovakia, Sweden, England, Russia, Italy, Turkey, Belgium, Denmark, Japan, Poland, and Holland.

Conspicuously absent were Germany and the United States. The former was not invited due to all-too-recent wartime considerations, while the latter chose not to attend because of then-president Hoover's assertion that America possessed no modern art.

While Hoover was not entirely correct, it is true that the Paris Exposition served to bring a new awareness to American designers and artists, who began to focus their efforts in the direction of modernism.

The period after 1925 is often differentiated from Art Deco and is consequently referred to as Art Moderne. It is also called "The Machine Age" as items made during this time of rapid industrialization have an obvious industrial/functional appearance, as opposed to the elegant and decorative Art Deco themes and treatments.

However, whether you choose to call it Art Deco or Art Moderne, this overall style was largely gone by 1940, having fallen victim to the rigors of the Depression, the public's changing taste, and the onset of World War II.

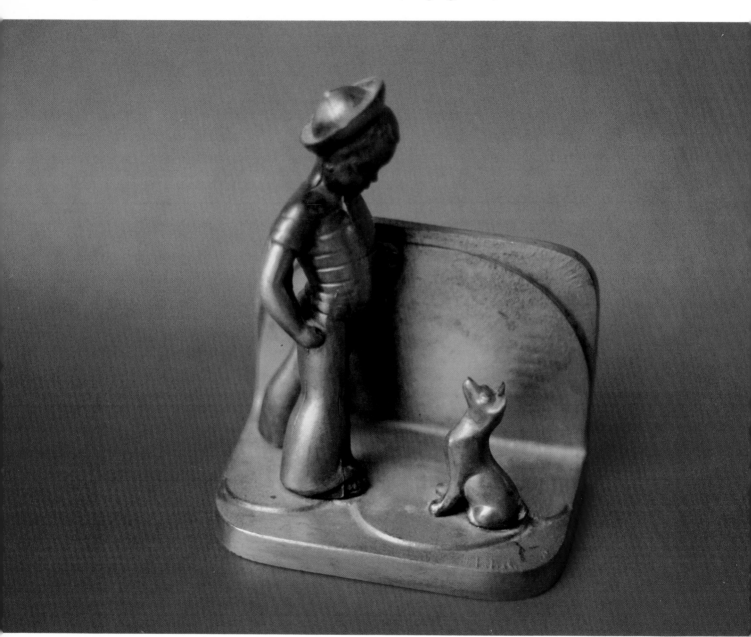

A 7" high Frankart bookend with stylized boy and dog design.

Prominent Manufacturers of Art Deco Items

The following section has been designed to provide the reader with such basic information as who, where, when, and what in regards to many of the prolific, well-known firms of the Art Deco era.

Although not all-inclusive, I have selected eighteen of the manufacturers whose wares are conspicuously featured in this book. They are alphabetically arranged, and it is hoped that these synopses answer your questions and offer some insight.

BENEDICT MANUFACTURING COMPANY

Location: East Syracuse, New York.
Period of Production: 1894 to 1953.
This company produced an extensive line of solid brass items as well as bronze-plated, silver-plated, and nickel-silver-plated objects, including but not limited to vases, boxes, desk sets, and candlesticks.

Two of Benedict's most popular patterns were "Karnak" and "Athenic Bronze," both of which were made during the Art Deco era, thus reflecting appropriate styles and themes of the times.

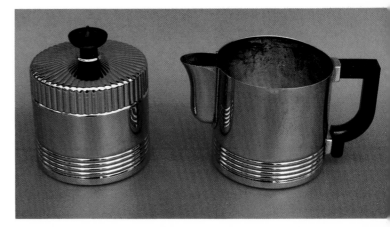

A 3½" high chromed copper creamer and sugar with black Bakelite fittings. Made by Chase.

THE CHASE BRASS & COPPER COMPANY

Location: Waterbury, Connecticut.
Period of Production: 1876 to circa 1941.
Primarily a manufacturer of industrial wares such as tubes and piping during its early years, The Chase Brass & Copper Company shifted production to decorative and useful chromium household items during the 1920s.

Benedict brass bookends in the Karnak pattern, 3" high, 5" long.

Chase's wide line of wares included lamps, ashtrays, bar accessories, and kitchen pieces, which were available in chromium, brass, and copper. Chase items are a favorite among Art Deco collectors because of the quality of the materials used and the strength of the designs, many of which were commissioned from such famous figures of the period as Russel Wright, Rockwell Kent, Gilbert Rohde, and Walter von Nessen.

Chase wares are invariably die-impressed with their unique and famous trademark—a centaur with a bow and arrow and the word "CHASE" below.

An 8½" high Cowan Pottery figural flower frog.

A 6" diameter Bizarre Ware plate by Clarice Cliff.

CLARICE CLIFF
Location: Burslem, England.
Period of Production: 1916 to 1938.
Clarice Cliff was an eminently talented artist who designed and directed the output of the Wilkinson and Newport Pottery Companies.

In all, she and her workers created and designed over 200 shapes and 200 designs. The most famous of these is her Bizarre Ware line, which included such vividly colored Art Deco patterns as "Latonia," "Applique," and "Crocus."

Clarice Cliff wares are clearly marked as such. Values vary greatly according to the form and pattern, with large or unusual Art Deco style items being the zenith.

COWAN POTTERY
Location: Cleveland, then Rocky River, Ohio.
Period of Production: 1912 to 1931.
Coming from a family of Ohio River Valley potters, Guy Cowan became a successful studio ceramist in his own right. Utilizing local red clays that he covered with high-quality glazes, Cowan developed a line of tiles and artware that he named and marked "Lakewood." These were sold through the Cleveland Pottery and Tile Company, which he established in 1913.

Cowan's success and reputation seemed to be ensured when suddenly World War I erupted. Production ceased, Cowan enlisted in 1917, and he returned home in 1919 after serving.

Having had several years to consider various possibilities, Cowan established a much larger, more commercially viable facility in Rocky River, Ohio. Making use of fine white clays imported from England, Cowan and artists under his employ (among them Viktor Schreckengost and Waylande Gregory) designed decorative figurines and artwares, many of which embody Art Deco styling.

Despite the commercial nature of this venture, most examples of Cowan are of exceptional quality and are becoming very popular with Deco collectors.

Most pieces can be identified by an impressed "Cowan" potter's mark.

A 13" high Farber Brothers "Krome-Kraft" cocktail shaker/server with Bakelite handle and cap.

FARBER BROTHERS
Location: New York City.
Period of Production: 1915 to 1965.
The firm of Farber Brothers manufactured an extensive line of nickel-plated, silver-plated, and chromium-plated hollowware as well as numerous solid brass items, all of which are very popular with collectors of Art Deco.

Of particular appeal are pieces incorporating glass or ceramic inserts, including Cambridge, Fenton, Lenox, and others. Farber Brothers products generally reflect superior designs and craftsmanship.

Chromium-plated wares were marketed under the trademark "Krome-Kraft." This line enjoyed its heyday in the 1920s and 1930s. Farber Brothers products are wide-ranging, and among them are bar items, serving accessories, smoking-related articles, and even decorative objects such as jardinieres.

Most examples are clearly impress-marked with the Farber Brothers name. They should not be confused with items marked "FARBER-WARE," which are the products of a third Farber Brother, who owned and operated his own company.

A 24" high Frankart figural floor ashtray. This is one of the most sought-after Frankart items.

FRANKART, INC.
Location: New York City.
Period of Production: Circa 1921 to circa 1931.
Decorative accessories were mass-produced by this company in the 1920s and 1930s, including figural ashtrays, lamps, bookends, vases, and more.

The favored themes were animals, birds, and especially nudes. The wares were cast in white

metal and factory finished with green, black, gray, or bronze-colored paint. Almost all examples are mold-marked "Frankart, Inc."

A group of 3½"-4½" Hagenauer stylized tribesmen, complete with their original grass skirts.

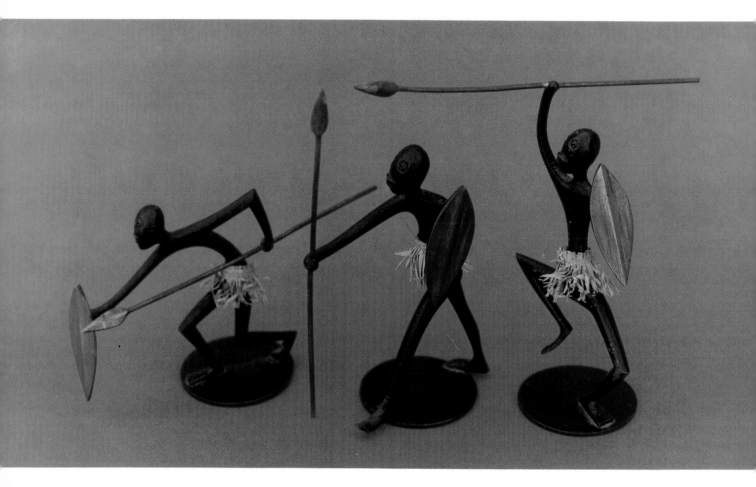

HAGENAUER WORKSHOPS

Location: Vienna, Austria.
Period of Production: Late 1920s to the early 1930s.

The Hagenauer Workshops were a branch of the Vienna Secession movement. Said workshops were similar to a guild in that the work was accomplished by numerous skilled artisans.

Much of the Hagenauer output was commissioned by the large and prominent Wiener Werkstatte or Vienna Workshops. The Hagenauer Workshops are famous for their sculptures/figurines, which were made from chromed metal, bronze, carved wood, or combinations thereof.

These figurines are highly stylized, with the most common being animals of about one inch in height. Larger figurines, busts, and odd items are coveted by collectors.

Most Hagenauer pieces are clearly marked.

THE HALL CHINA COMPANY

Location: East Liverpool, Ohio.
Period of Production: 1903 to the present.

Originally a producer of simple utilitarian items that included chamber pots, jugs, slop jars, and bed pans, Hall devoted many years to experimentation with sophisticated glazing and firing techniques.

This experimentation eventually led to their manufacturing of restaurant and institutional wares, which in turn culminated in Hall's development of a wide-ranging line of teapots, refrigerator ware, and dinnerware, for which they are famous.

Examples of Hall china from the 1920s and 1930s are prized by Art Deco collectors, especially some of the more unusual teapots like the Doughnut, the Automobile, and the World's Fair.

Hall wares usually can be identified by the

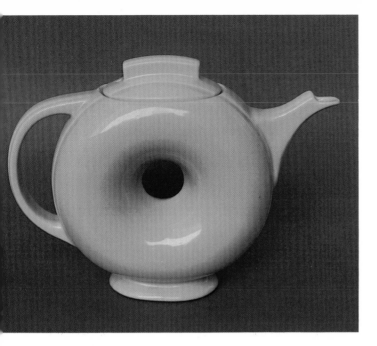

An 8" high Hall China "Donut" teapot.

presence of an ink-stamp mark. Most objects made after 1972 bear a bold letter mark comprised of the word "Hall" within a rectangular border.

HEINTZ ART METAL SHOP
Location: Buffalo, New York.
Period of Production: 1906 to February 11, 1930.
This company produced a wide variety of both ornamental and useful bronze items decorated with sterling silver overlays of Art Nouveau, Art Deco, and Arts and Crafts design. Among the articles made were smoking sets, lamps, jewelry, vases, bookends, and much more.

A Heintz Art Metal trophy/loving cup made from sterling-decorated bronze. Strong geometric handles and overlay.

Most Heintz wares bear an impressed mark consisting of the letters HAMS enclosed within a diamond, and directly below it the words, "STERLING ON BRONZE, PAT AUG 27.12."

In 1919 Heintz's head salesman, Fred C. Smith, quit the firm and took many of the best metalworkers with him. Together they founded the Smith Metal Arts Company, which manufactured similar wares.

LALIQUE
Location: Combs-la-Ville, then Wingen-sur-Moder, France.
Period of Production: 1909 to the present.
Rene Lalique began his impressive career as a creator of Art Nouveau jewelry. During the early 1900s, he began to experiment with glasswork, which led entrepreneur Roger Coty to commission him to create a line of perfume bottles.

Lalique's great talent as a designer and innovator gained him an enduring reputation as the most famous of glassmakers. The Lalique factory mass-produced an incredible variety of

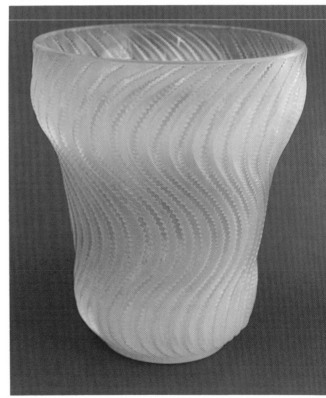

A lovely 8⅝" high R. Lalique opalescent glass vase highlighted with relief-molded curvilinear, serrated designs.

13

functional and decorative objects in up to ten different colors.

The emphasis of Lalique glassware was on naturalistic themes such as women, fish, insects, and foliage. Items made prior to Lalique's death in 1945 are marked "R. Lalique" or "Rene Lalique."

Lalique glassware is still being made today. These current creations are of lead crystal, marketed under the name "Cristal Lalique" and are marked "Lalique France."

MANDALIAN MANUFACTURING COMPANY

Location: North Attleboro, Massachusetts.
Period of Production: Circa 1900 to circa 1940.
Metal mesh bags with colorful enameled designs were the mainstay of this firm. Their products are almost always marked on the inside of the clasp with a small die-impressed "MANDALIAN MFG CO USA" mark.

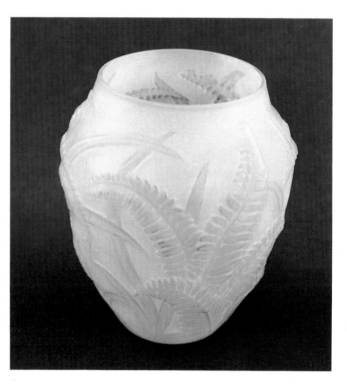

A classic Phoenix glass vase with relief-molded ferns contrasted against a frosted background, 7½" high.

PHOENIX GLASS COMPANY

Location: Monaca, Pennsylvania.
Period of Production: 1880 to circa mid-1950s.
Although they made a variety of wares, the Phoenix Glass Company is best known for their highly decorative relief-molded vases and bowls of the 1930s and 1940s, which highlighted floral motifs, birds, and cavorting nudes.

Phoenix's Sculpted Artware was originally marked with paper labels, which are rarely intact. However, their products can usually be identified by their general use of colored backgrounds contrasted with uncolored relief-molded motifs.

Enameled mesh evening bag with conventionalized floriform designs. Nickel-silver chain and clasp, the latter set with colored rhinestones. Made by the Mandalian Mfg. Co. of North Attleboro, Massachusetts.

Similar glassware made by the Consolidated Lamp & Glass Co. of Coraopolis, Pennsylvania, largely featured colored relief molding on a plain ground.

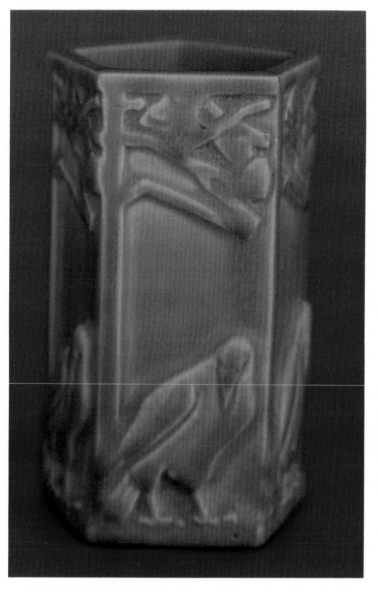

This charming pentagonally shaped vase was made by the Rookwood Pottery and each panel is appropriately decorated with relief-molded rooks. It is 4¾" high and is dated 1934.

THE ROOKWOOD POTTERY COMPANY
Location: Cincinnati, Ohio.
Period of Production: 1879 to 1967.
Founded by the wealthy Maria Longworth Nichols Storer, this enterprise truly embraced the concept of "art" pottery, with most examples made prior to 1900 being hand-thrown and decorated.

Shortly after the turn-of-the-century, much of Rookwood's focus shifted to mass-production. These mold-made pieces included vases, inkwells, candlesticks, and more.

Many of the items made by Rookwood during the 1920s and 1930s reflect Art Deco styling. Such examples are affordable and popular with collectors.

Rookwood pottery is recognizable by their famous impressed mark consisting of a reversed "RP" abbreviation surrounded by flame points. Below this mark are Roman numerals that date the year in which the piece was made.

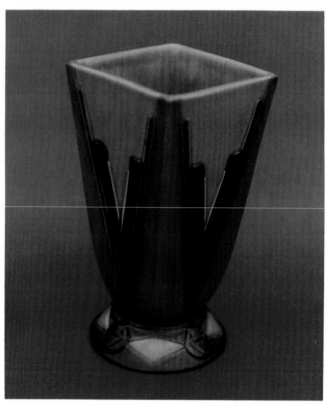

An 8" high Roseville Futura "V" vase. Note the strong overall geometric treatment.

THE ROSEVILLE POTTERY COMPANY
Location: Roseville, then Zanesville, Ohio.
Period of Production: 1892 to 1954.
Roseville art pottery is among the most famous and widely collected of all ceramics. Many of the patterns that they produced during their "Middle Period" (or the 1920s and 1930s) are sought by Art Deco enthusiasts.

Without a doubt, Roseville's "Futura" line made in 1928 is considered one of the hallmarks

of the period because of its ultramodern designs, which often incorporated severe geometric forms.

Much of the Roseville Pottery manufactured in the 1920s and 1930s was marked with paper labels, which are usually absent. Identification is possible through the use of old production catalogs and appropriate reference books.

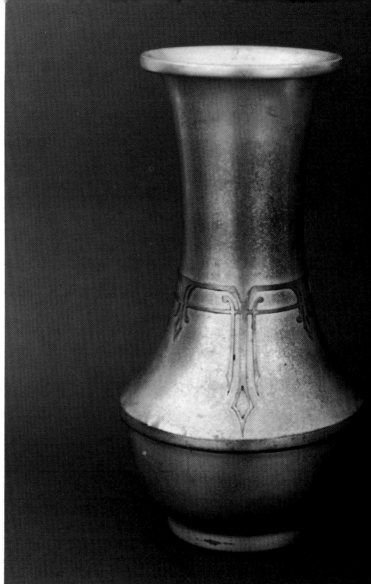

Silvercrest 7½" and 8" high Classical design vases. Acid-etched bronze with gold-plating.

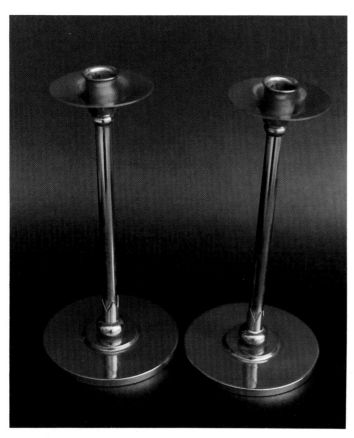

A pair of Roycroft 9¼" high Art Deco style copper and brass candlesticks.

ROYCROFT COPPER SHOP
Location: East Aurora, New York.
Period of Production: 1906 to 1938.
Although the Roycroft Copper Shop and its products are largely identified with the Arts and Crafts Movement, many of the copper objects they made during the 1920s and 1930s reflect Art Deco styling, this due to the changing tastes of the buying public.

Roycroft items are generally marked with an impressed symbol consisting of a stylized cross, below which is the letter "R" within an orb. Objects made from 1915 to 1938 additionally bear the impressed word "ROYCROFT."

SILVERCREST (SMITH METAL ARTS CO.)
Location: Buffalo, New York.
Period of Production: April 24, 1919, to the present. Solid bronze decorative objects such as vases and bowls, as well as functional items like desk sets, lamps, and picture frames, were manufactured. Products made by this firm during the 1920s bear an impressed "Silvercrest" trademark and display strong Art Deco designs. Pieces made after 1930 are simply marked SMACo.

THE WELLER POTTERY COMPANY
Location: Zanesville, Ohio.
Period of Production: 1872 to 1945.
This well-known firm mass-produced art pottery for decades, including the duration of

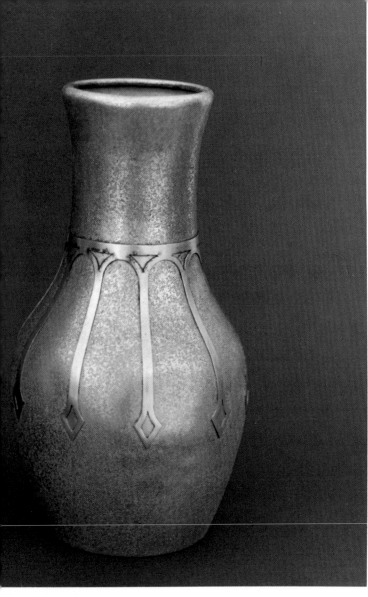

the Art Deco era. Some of Weller's best designed and most sought-after patterns of the 1920s and 1930s would include Atlas, Lorbeek, Hobart, Ragenda, Darsie, and others.

Most examples from this period are marked with either an ink stamp, impressed mark, or in-mold script.

WHITING AND DAVIS COMPANY

Location: Plainville, Massachusetts.
Period of Production: 1876 to the present.
Whiting and Davis is the largest and oldest manufacturer of purses and accessories in the United States. Whiting and Davis's mesh purses have been made in a wide variety of gauges, styles, and materials over the years. They are generally marked "Whiting and Davis Mesh Purses" on the inner clasp with either an impressed mark or a small attached metal tag.

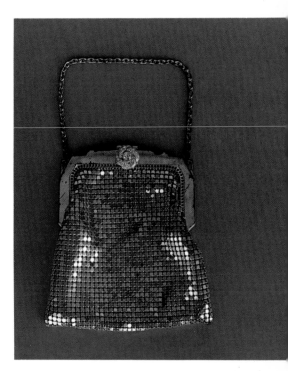

A 7½" long Whiting and Davis mesh purse with a circular rhinestone clasp.

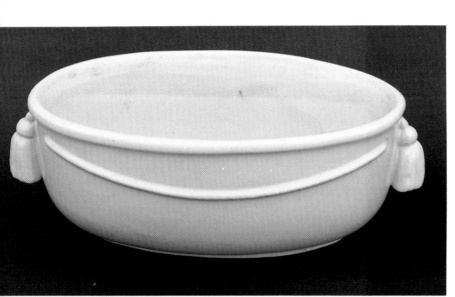

A 4¼" high, 12" long Weller planter in the Darsie pattern. This piece dates from 1935 and is marked "Weller Pottery" on the base with an in-mold script.

Chapter Three

Art Deco Terminology

Animalier Movement: Animals, birds, and even insects of all kinds (particularly the jungle cats) were favored themes during the Art Deco era and were widely utilized in every way and form. It was only when some of these motifs were adopted by Germany's Third Reich that they quickly lost their appeal.

Art Deco: A style that emerged and evolved during the first four decades of the twentieth century—partially as an opposition to Late Victorian/Art Nouveau themes. Art Deco is characterized by clean, striking, colorful designs involving geometrics, streamlined motifs, human and animal figures, concepts of speed and motion, and futuristic visions.

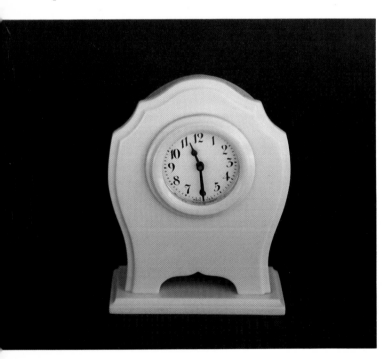

A 6¼" high celluloid shelf or dresser clock. It is marked "MADE IN USA."

Art Moderne: A term given to much of the architecture as well as the accessories made during the late 1920s through the 1930s. These "Machine Age" items generally reflect an industrial/functional appearance.

Bakelite: This first entirely man-made substance was discovered and named in 1908 by the chemist Dr. Leo Baekland, who was seeking to invent a superior electrical insulator. Bakelite is a phenolic resin, which when subjected to great heat and pressure (polymerization) undergoes a chemical change altering it to a hard, unmeltable state. Ultimately suitable for carving, polishing, or molding, this colorful, durable, and inexpensive material was widely utilized during the 1920s and 1930s. It can usually be distinguished from other modern plastics by virtue of the fact that it is heavier, opaque, and cannot be melted.

Catalin: One of the modern plastics of the twentieth century, catalin is often mistaken for Bakelite, but can usually be differentiated by its semitranslucent, swirled colors.

Celluloid: Dating from circa 1870, celluloid is the earliest plastic. It is made from a combination of sulfuric and nitric acids in addition to plant fiber. It is technically a thermoplastic because it is highly flammable (and impractical when compared to Bakelite). Nevertheless, it was popular during the 1920s and 1930s as it was inexpensive and simulated ivory.

Paris Exposition of 1925: Considered by many to be the definitive pinnacle of the Art Deco period, this exposition showcased the best modernistic objects and accessories from artists and designers worldwide.

Spelter: A zinc-based metal alloy used by many manufacturers (such as Frankart) to cast figurines, bookends, and other items. Spelter objects were usually given a painted or bronzed finish to enhance their appearance.

Wiener Werkstatte: Established by Joseph Hoffmann in Austria in 1903, this workshop made innovative, seminal contributions to geometric and modern design. Such designs had a far-reaching influence during the Art Deco period, particularly in America, where many of the Austrian artists immigrated when the workshops went bankrupt in 1932.

A particularly unusual and possibly unique console table made from cast aluminum with a polished marble top. A fine representative example of the *animalier* movement. It measures 28½" high and 41" long.

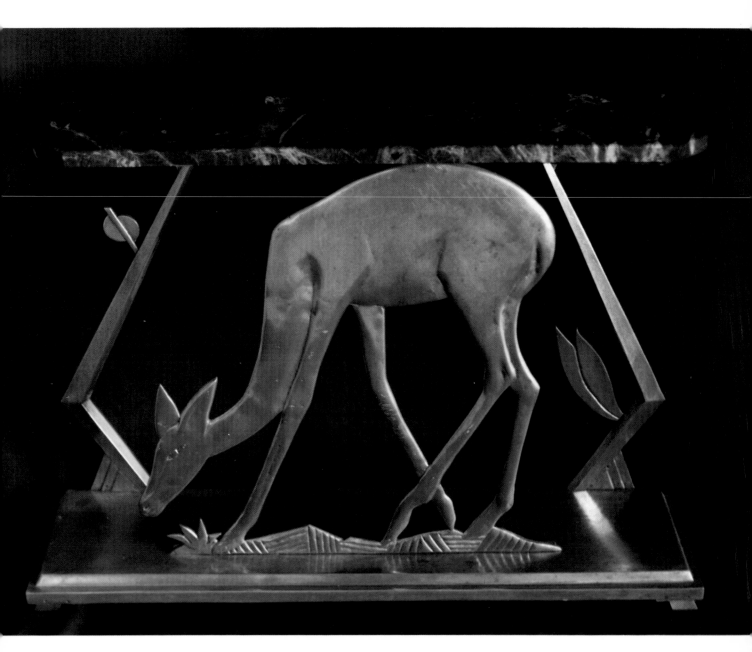

Art Deco Rarity Chart

Fortunately for the collecting public, the great majority of Art Deco items are available and affordable. The obvious exceptions are strongly designed examples by specific makers (such as Frankart), which are considered hallmarks of the period and carry commensurate price tags.

In addition, there are those items that were expensive when they were made (like R. Lalique) and have rocketed in value accordingly.

The following chart will give you a general idea of what to expect to see and pay in the Art Deco marketplace.

Group One/Common: Benedict items; most chromeware (including Chase and Farber Brothers); mesh and beaded purses; Czechoslovakian glassware; most costume jewelry;

bookends; dresser accessories; the majority of dinnerware; small Phoenix Glass pieces; most bar, desk, and smoking items.

Group Two/Relatively Rare: Roseville Futura, Frankart lamps and figurines, unusual Hall teapots, well-designed French marble mantle clocks, large Heintz and Silvercrest vases, most Boch Freres vases, large Cowan items, the majority of table lamps (particularly unusual ones).

Group Three/ Rare and Expensive: bronzes, large examples of Hagenauer, Ronson figural lighters, unusual carved and articulated Bakelite jewelry, large and distinctive Clarice Cliff pieces, major pieces of French art glass by R. Lalique and Legras, colorful catalin radios.

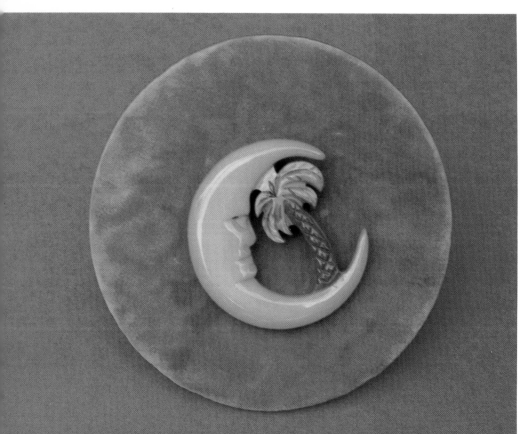

A rare and desirable carved Bakelite moon and palm tree pin.

Recognizing Reproductions

If you're intending to collect Art Deco, it's imperative that you be able to differentiate old from new before investing in any expensive pieces.

With few exceptions, said expensive pieces are costly because they were made by a renowned company or person. These firms or individuals were proud of their work when they made it, and almost invariably marked it with their name.

As such, my point is this: Do not let someone sell you an unsigned item that they attribute to be something special and valuable. Instead of adding an unmarked piece of Frankart or Chase to your collection, chances are you'll end up with an overpriced fake.

This is especially true in the case of Frankart. The original molds have been sold and are being used to grind out unsigned replicas. Regardless of how good an item looks, don't be fooled—only pay a premium for well-marked examples.

Additionally, there are those firms that have been in business for decades and whose current products are stylistically faithful to their output during the Art Deco decades.

Such firms would include Lalique and Sabino, and although their contemporary work is lovely, of excellent quality, and is valuable in its own right, these items should not be mistaken for old, original examples.

In the case of new Lalique glassware, it is marked "Lalique, France" as opposed to pre-1945 items that bear the designation "R. Lalique". Present-day Sabino glass is characterized by a distinctive fiery opalescence, examples of which can be seen in most jewelry stores.

Before spending your money, spend some time looking, studying, and making contact with reputable dealers.

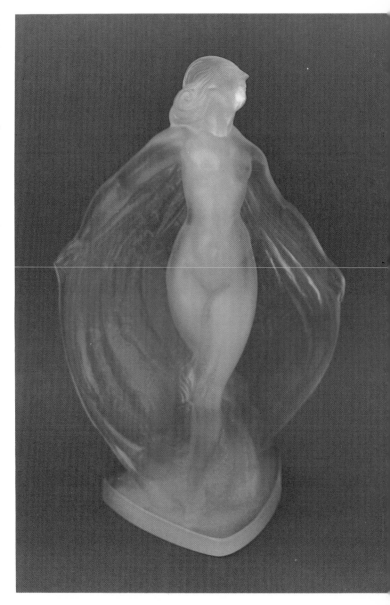

A lovely but modern example of Sabino art glass in the form of a 10″ high figurine of Isadora Duncan.

Art Deco Photos, Descriptions, and Prices

Art Glass

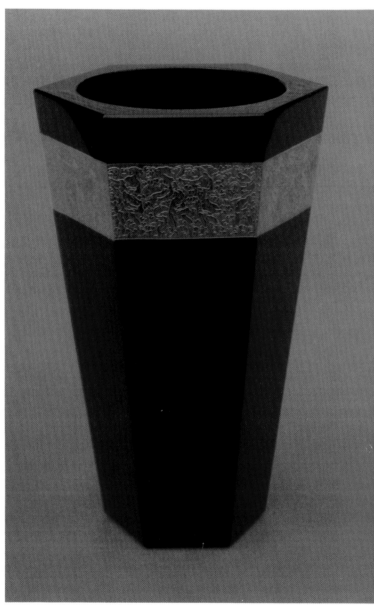

A 10″ high tortoise-shell vase designed to resemble a Grecian column.

An 8¾″ high Moser hexagonal vase. Dark amethyst coloring with a deeply carved and gilt band of classical figures.

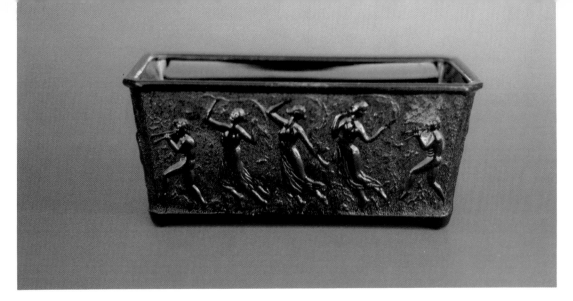

This black amethyst window planter is decorated with a panorama of dancing maidens and satyrs. It was made by the L.E. Smith Glass Company of Mt. Pleasant, Pennsylvania, and measures 3¼" high, 8" long, and 3½" wide.

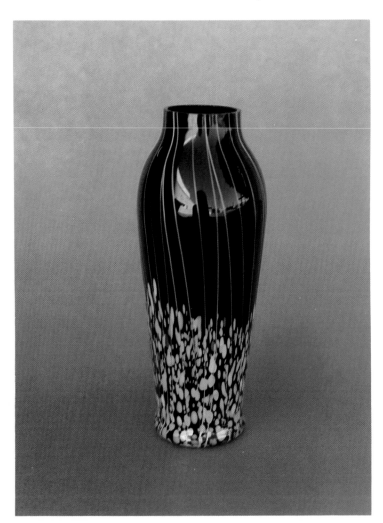

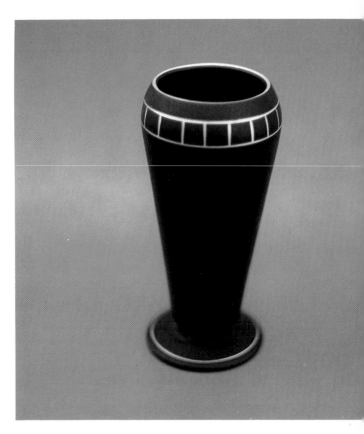

This beautiful black satin glass vase with Art Deco gilding was made by the Tiffin Glass Company of Tiffin, Ohio. It measures 6½" high.

A 10" high Czechoslovakian art glass vase of striking, contrasting colors.

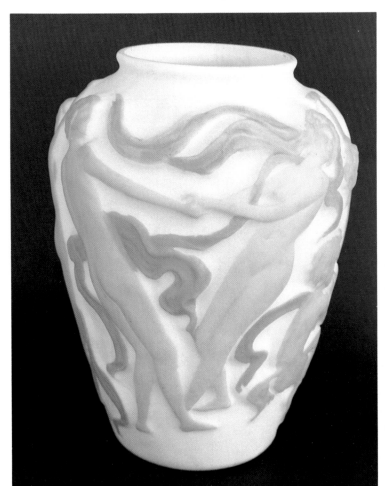

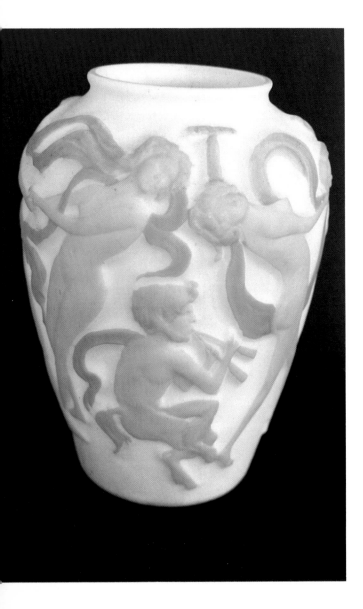

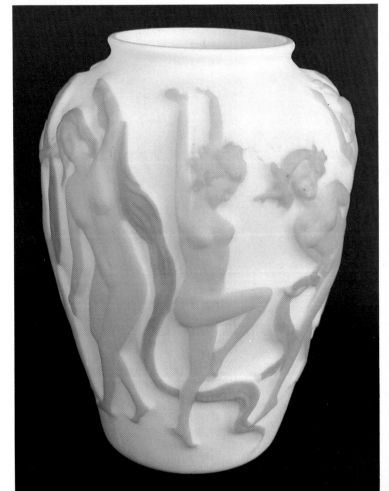

Three views of a stunning Phoenix Glass vase featuring relief-molded dancing nudes and a pipe-playing satyr. The vase measures a full 12″ high.

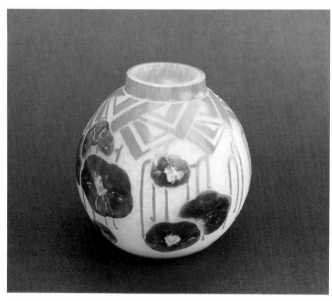

A 4½" high Le Verre Francais cameo-style vase embellished with geometrized organic designs in acid-cut relief.

A fine example of Verlys glass, 10" high, with highly relief-molded and frosted organic forms.

An 8½" high Imperial slag glass vase. Classical styling with relief-molded dancing figures.

An impressive and important Legras art glass vase formed from dark green glass that has been cut, etched, and frosted with geometric devices. It measures 10″ high.

A beautiful 17" diameter molded amber glass tray block-signed "R. LALIQUE."

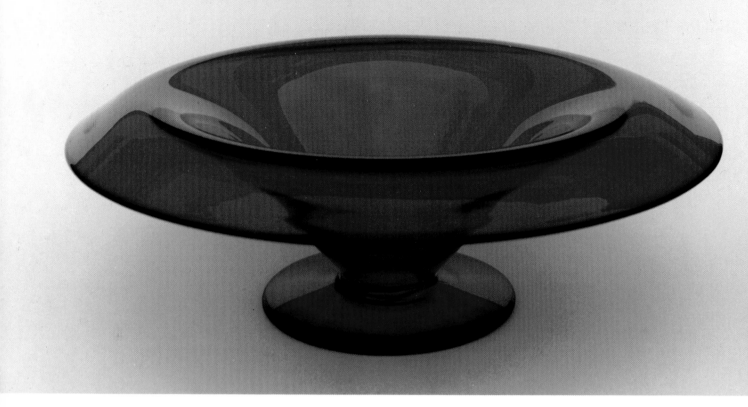

Red art glass bowl/compote of modernistic design. Hand-blown and formed.

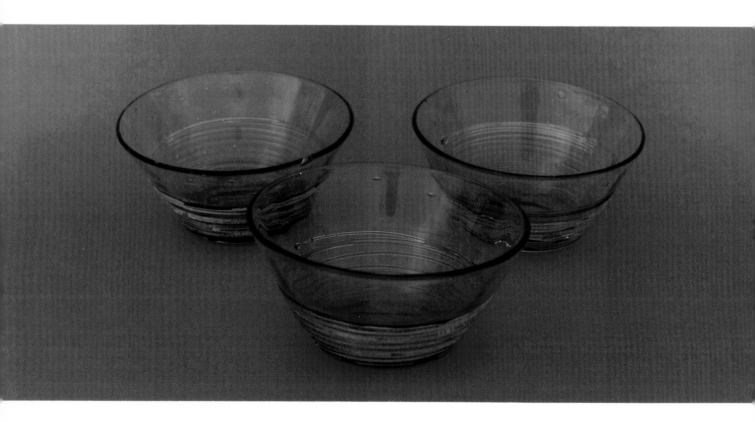

Steuben bowls with controlled internal bubbles and applied rings of glass. Each is 4″ in diameter and 2¼″ high.

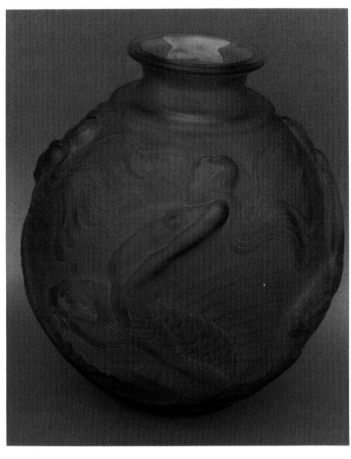

A highly relief-molded frosted amber glass vase with mermaid theme. Czechoslovakian; 10" high.

A 10¾" diameter R. Lalique plate of opalescent glass with an embossed swimming nudes motif.

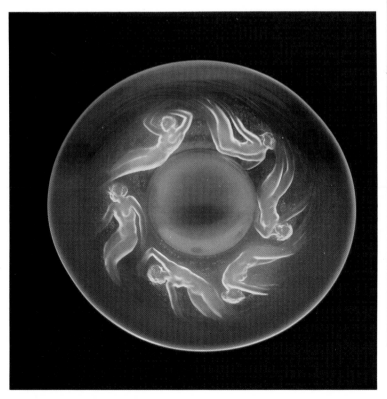

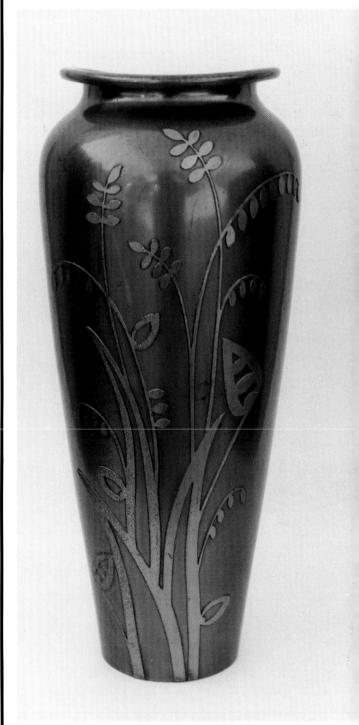

A 13" high bronze vase decorated with an elaborate overlay of abstract organic forms. This piece is marked "Silvercrest."

This 8¾" high handled vase was made by the Benedict Manufacturing Company. It is marked "Benedict" as well as "Athenic Bronze," which is the pattern.

Silvercrest vase with green patina and sterling conventionalized floral overlay, 9¾" high.

A 14½" high Silvercrest polished bronze loving cup/vase with a sterling silver Art Deco style overlay.

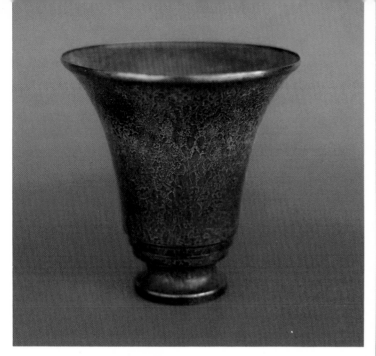

Made and marked by Philadelphia metalsmith Carl Sorensen, this spun bronze trumpet-form vase is 6" high and exhibits a vivid blue-green "snakeskin" patina.

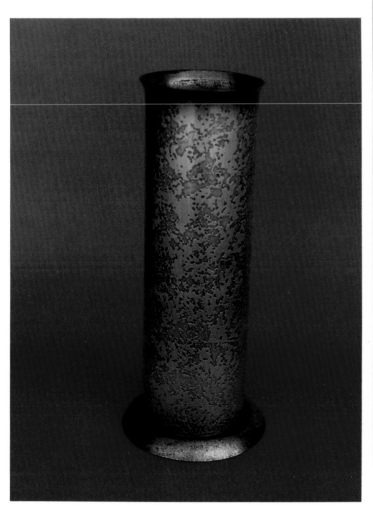

A 10" high Roycroft vase of severe, functional design.

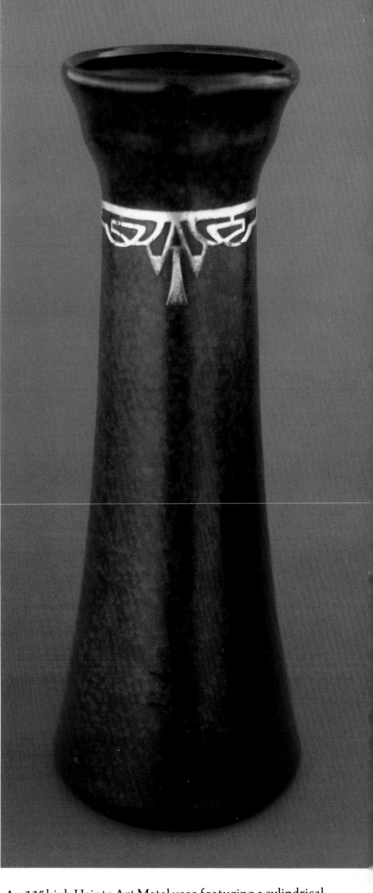

An 11" high Heintz Art Metal vase featuring a cylindrical body with expanded mouth and streamlined sterling overlay.

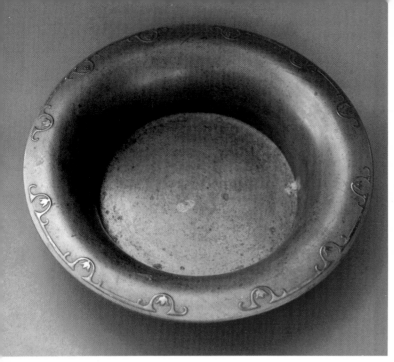

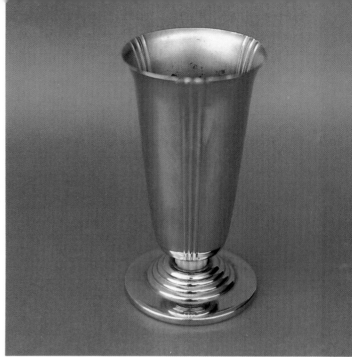

A 2" high, 11" diameter bronze bowl with shouldered rim and modernistic sterling floral overlay. The base of this bowl is marked SMACo (Smith Metal Arts Co.).

A 6½" high Chase chrome and Bakelite vase with sleek, streamlined appearance.

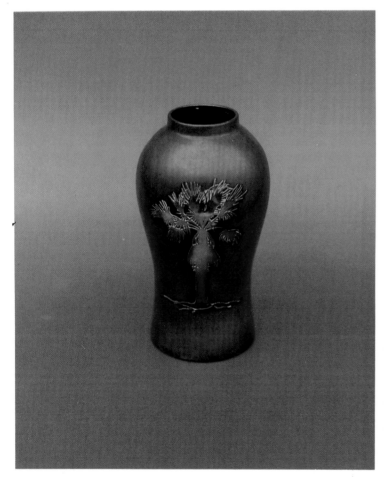

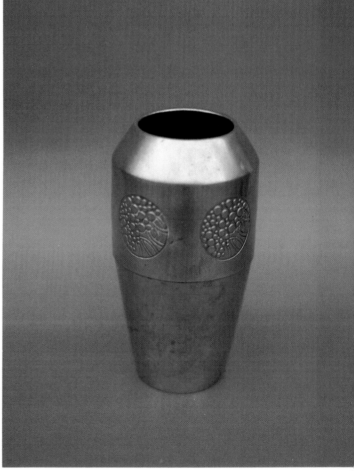

A 6¼" high Heintz bronze vase with sterling palm tree overlay.

A 7" high brass Art Deco vase by WMF, Germany.

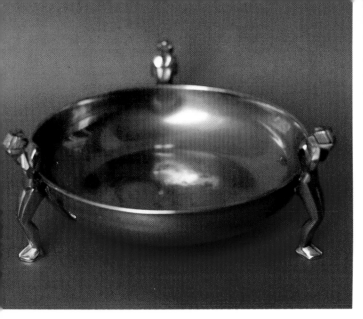

A 3½" high, 9" wide chrome bowl with cubistic female figural supports.

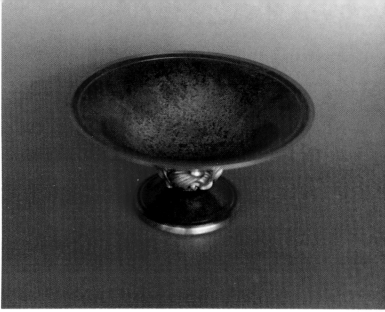

A 3¼" high, 6½" diameter Carl Sorensen bronze compote with lovely brownish-green patina.

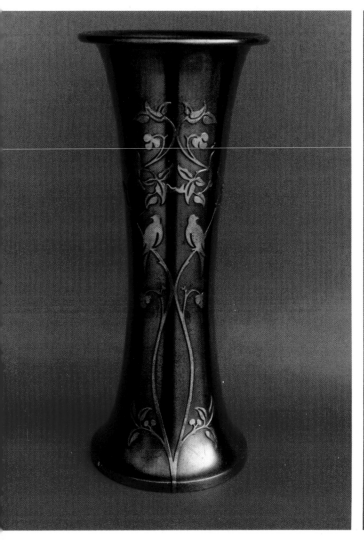

11¾" high bronze Silvercrest vase with a streamlined overlay of leafage, vines, and birds.

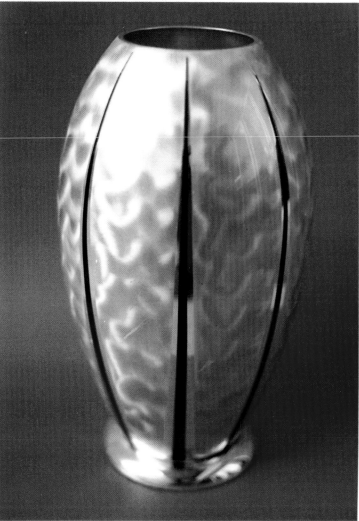

An 11½" high WMF, Germany vase made from highly polished chrome and black enamel over brass.

An 11½" long, 5" wide hammered copper tray made by Craftsman Studios of Laguna Beach, California. Note the stylized classical motif.

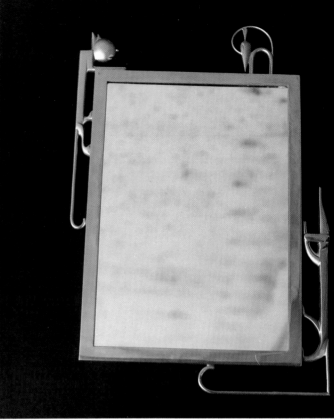

An absolutely stunning Hagenaeur mirror framed by super-stylized cartoon characters and animal forms, 17" long, 11" wide.

Art Pottery

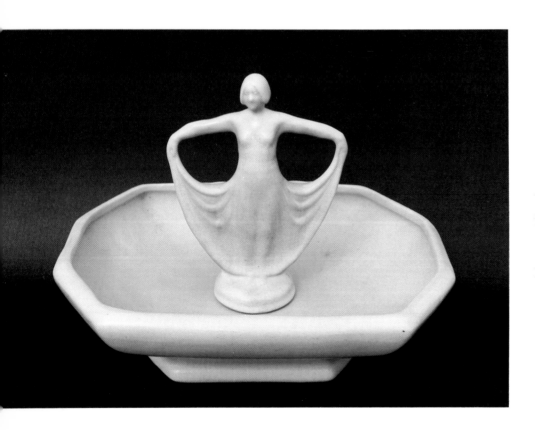

Weller Pottery figural flower frog and matching console bowl. Both were made during the 1920s, bear the Weller Ware ink stamp, and are part of the line/pattern known as Hobart. Overall height is 12".

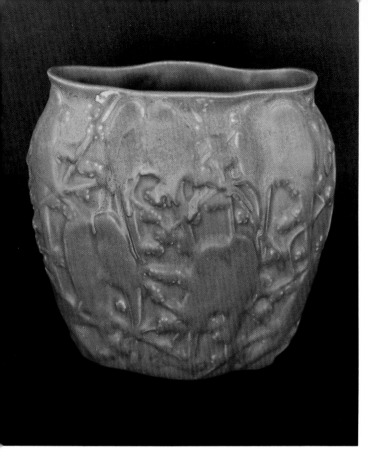

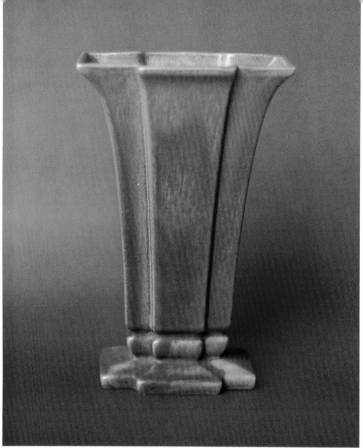

A 9″ high Muncie Pottery vase with relief-molded branches and birds. Muncie produced a line of vases such as this one that were approximate copies of Phoenix Glass examples of the period.

An 8½″ high Cowan Pottery vase exhibiting a strong geometric design.

A 4½″ high, 12″ diameter Wedgwood and Co. ceramic console bowl.

Ceramic planter with strongly stylized bird-form, 7"
high, 17½" long.

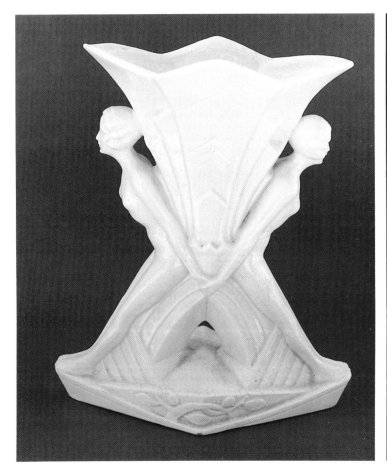

A 10" high white-glazed figural art pottery vase.

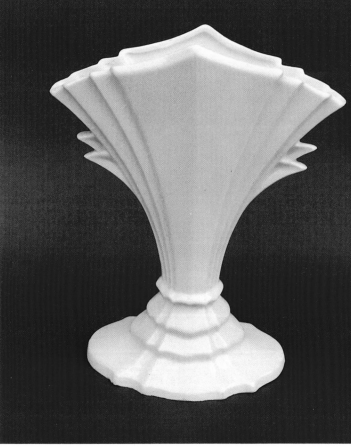

Czechoslovakian fan vase of clean, geometric design,
9¼" high.

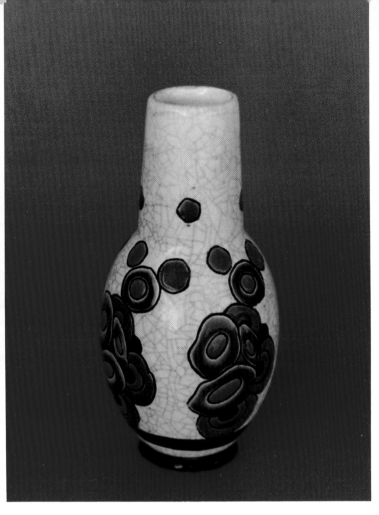

A 7" high Boch vase of particularly fine Deco design and coloration.

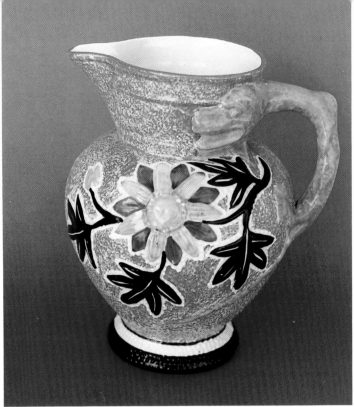

A phenomenal 9½" high Clarice Cliff Bizarre Ware dragon-handled jug.

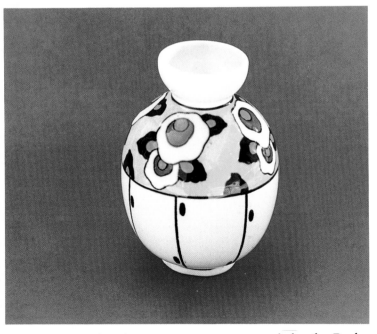

A 4¾" high Belgian art pottery vase made by the Boch Freres factory. Hand-decorated and signed by the artist, Lison.

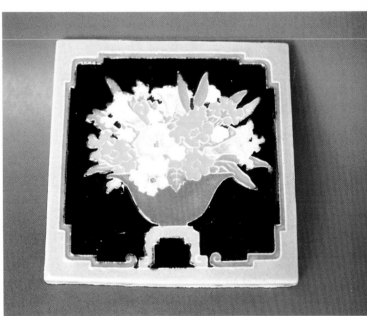

An 8" square Claycraft architectural tile displaying a stylized bouquet of flowers.

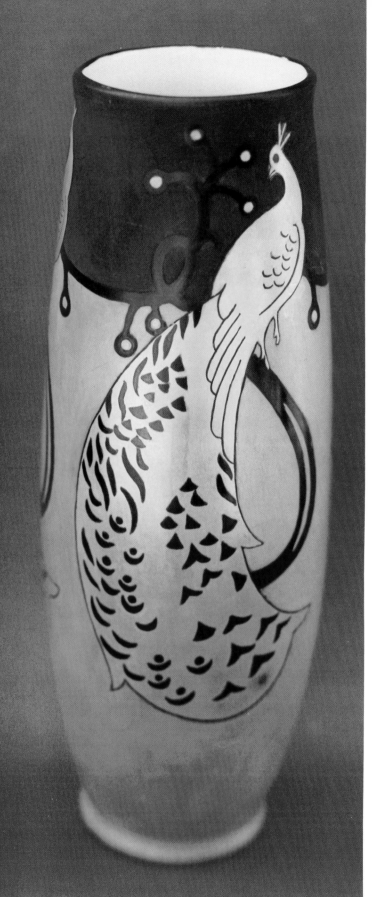

A Royal Staffordshire jardiniere of simple, streamlined design. It stands 8" high, 9½" in diameter.

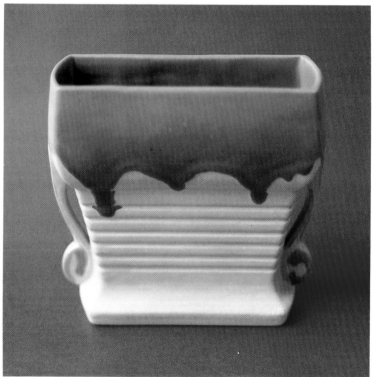

A 10½" high hand-decorated Czechoslovakian Art Deco vase.

A 6¼" high Roseville Pottery vase in the Carnelian pattern.

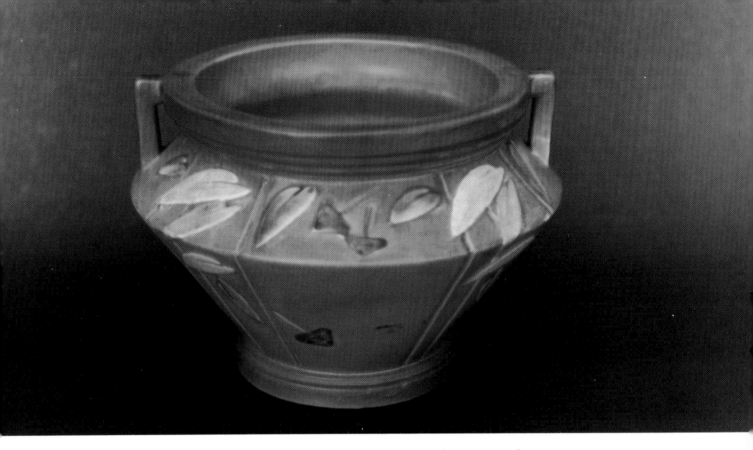

A 6" high Roseville "Futura" jardiniere of appropriately modern design.

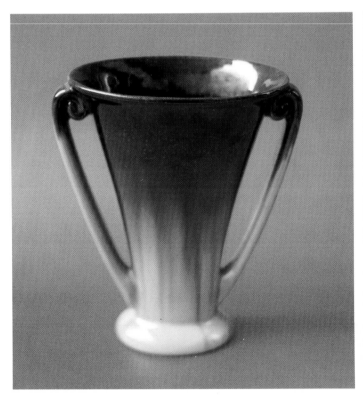

Handled Fulper Pottery fan vase with dark brownish green over butterscotch glaze, 8" high. Base is marked "Fulper."

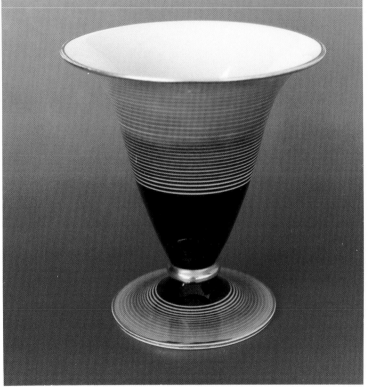

A 7¾" high Rosenthal of Bavaria porcelain vase with stunning coloration and patterning.

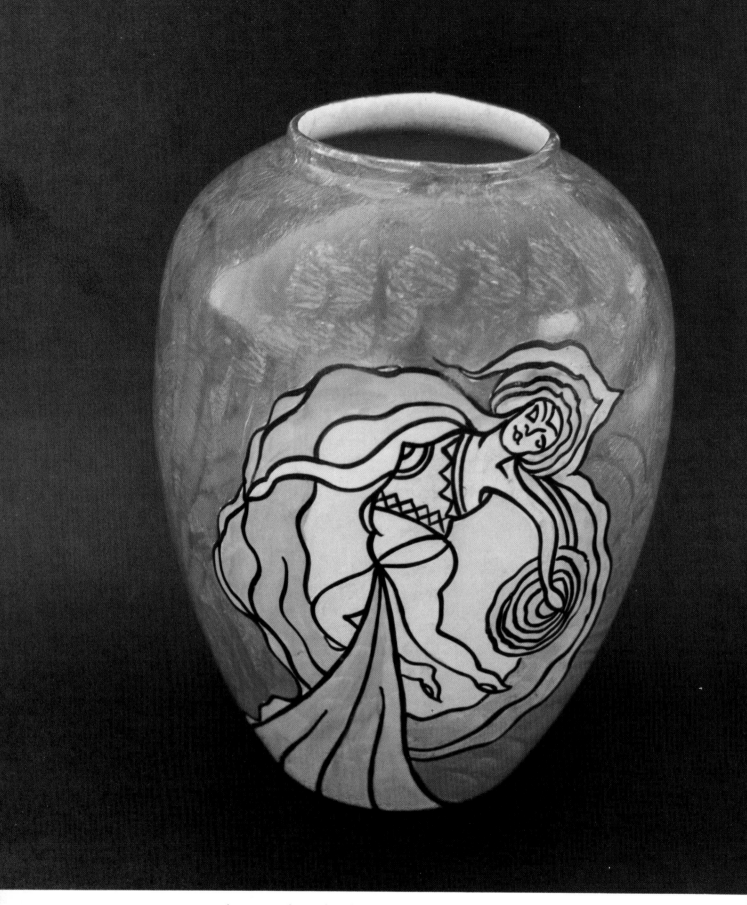

An extraordinary hand-decorated Camark vase, measuring 8½" high.

A Stangl console bowl exhibiting strong Deco lines and form, 6″ high, 10½″ long.

A 5″ high Zsolnay (Hungary) vase with iridescent metallic green glaze.

Chrome cocktail set consisting of shaker, 6 goblets, and undertray. Tray is 15″ long by 11″ wide, overall height is 9¾″.

Bar Accessories

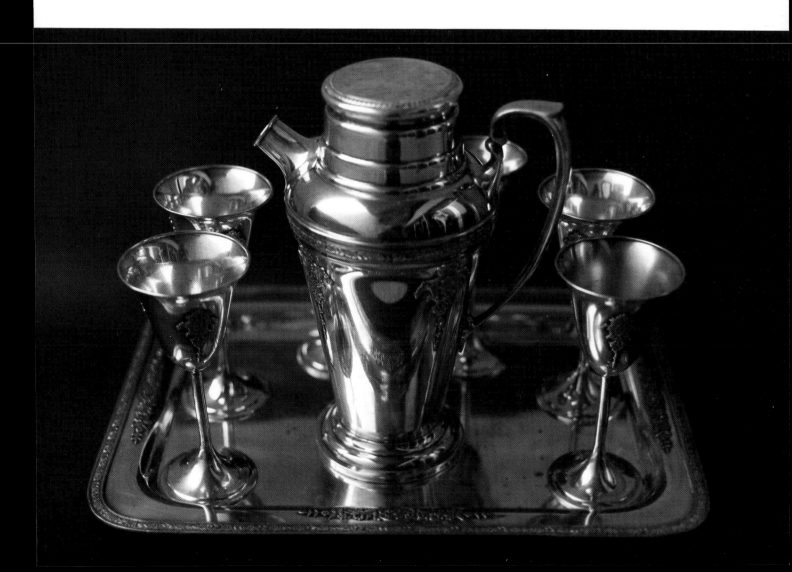

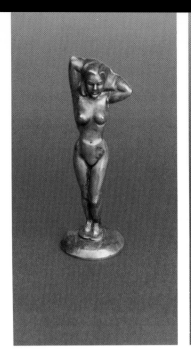
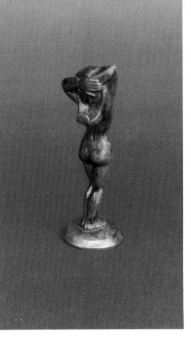
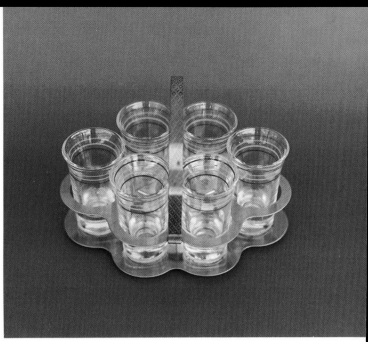

Front and back views of a 4½" high figural nude bronze bottle opener. No maker's mark.

Shot glass set and chrome carrier. Overall height is 5", overall length is 7".

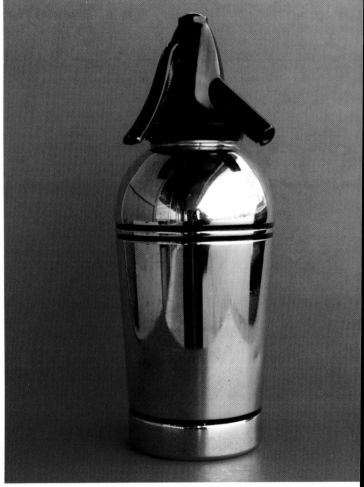

A 12" high cocktail server. Hand-blown, with applied handle foot and rings.

A 7" high chrome seltzer dispenser with black enamel decorative bands. Marked "Sparklet Devices Inc., Irvington, N.J."

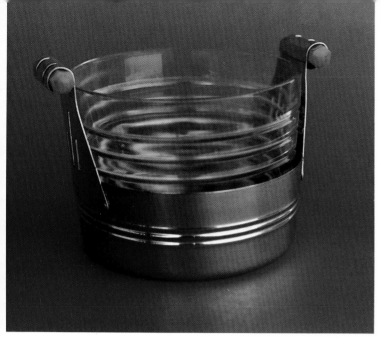

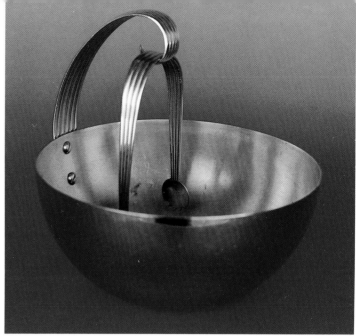

A 5" high, 7" diameter ice bucket consisting of a glass insert and a chrome framework with Bakelite handles. Decorative concentric rings add to the visual quality of this piece.

A Chase chromed metal ice bucket with matching tongs. This particular item was designed by Russel Wright.

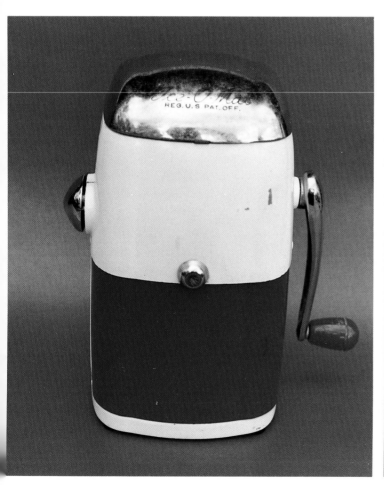

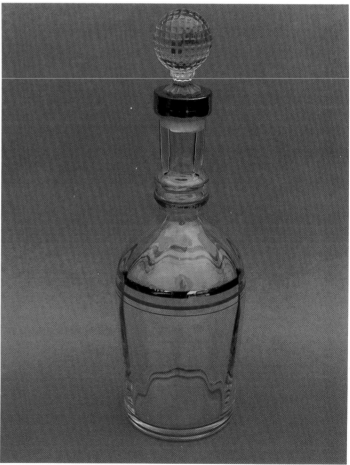

A 9" high Ice-O-Mat ice crusher made from chromed steel, painted aluminum, and red plastic.

Czechoslovakian liquor decanter with enameled patterning and golf ball stopper, 12" high.

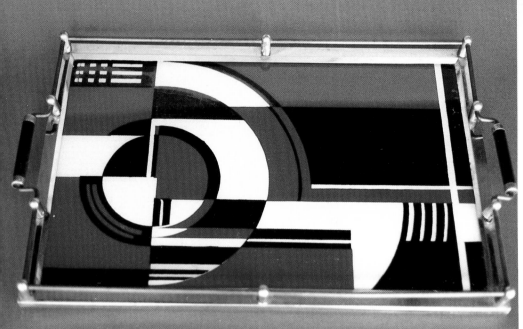

An 18″ long, 12″ wide drink-serving tray made from chromed metal and reverse-painted glass.

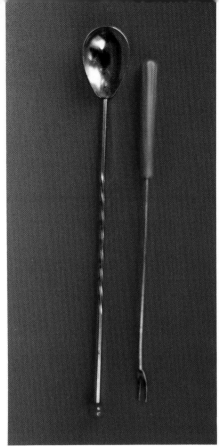

A 10½″ long cocktail stirrer and a 8¾″ long olive fork, both with Bakelite fittings.

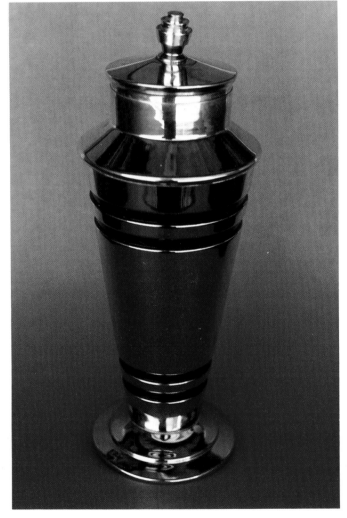

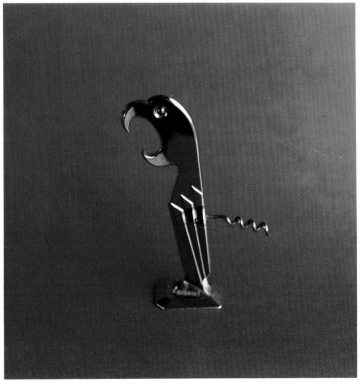

A visually attractive 12″ high chrome-plated cocktail shaker further enhanced by black enamel banding.

A 5⅛″ high chromed steel parrot bottle opener/corkscrew of exceptional design. Marked "Negbaur."

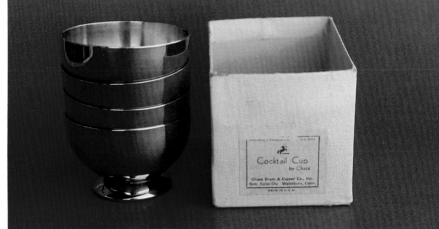

Chase chrome cocktail cups shown with the original box. Each cup is 2″ high and 3″ in diameter.

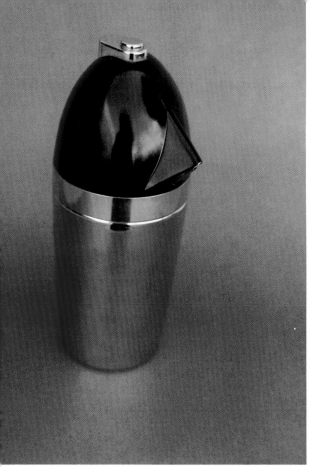

A 10″ high bullet-form Soda King Siphon designed by Norman Bel Geddes.

A 7¾″ high cobalt and clear glass cocktail stem incorporating a nude female figure. Made by the Cambridge Glass Company.

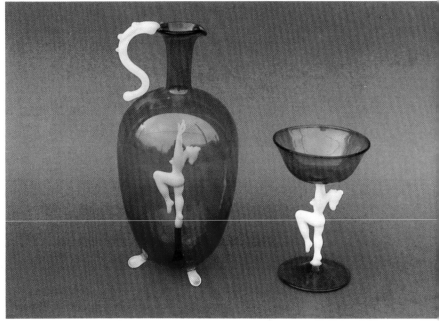

A 7″ high blown glass liqueur decanter with interior nude figure and a set of six matching 4″ high stems (one shown).

Six-inch high ceramic cocktail glasses with attached stylized female figures.

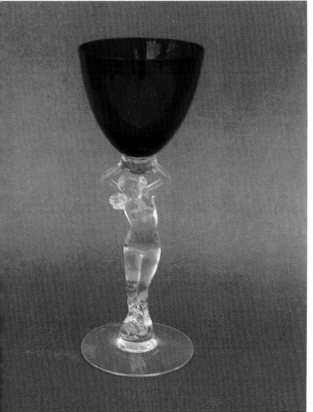

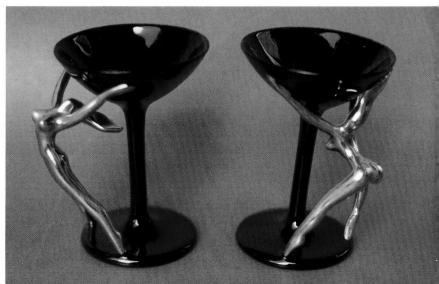

A 16" long by 12" wide chrome bar tray with blue glass inserts.

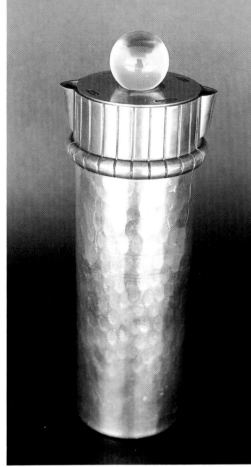

An 11½" high hammered aluminum drink shaker/server with a lucite knob on the lid. The base is marked "BUENILUM."

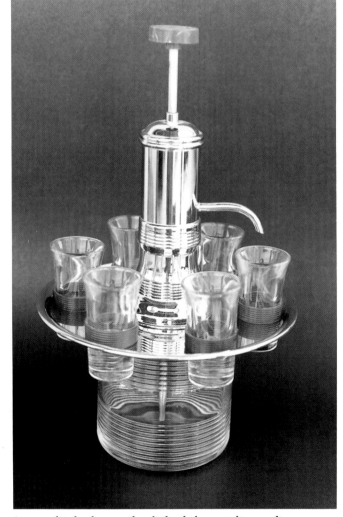

A 13½" high glass and polished chrome liquor dispenser. The circular tray rotates so that each shot glass can be filled.

A 7" high Czechoslovakian green and black glass liquor decanter with etched geometric designs.

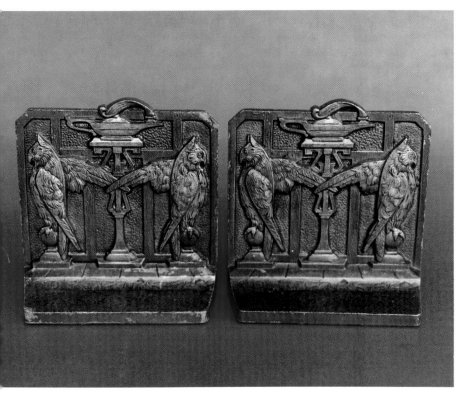

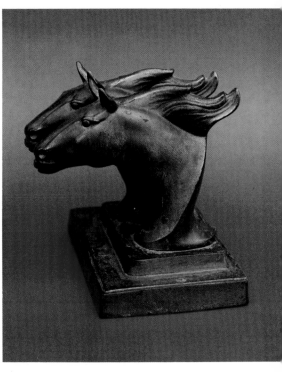

Gilded bronze bookends highlighted with stylized owl motifs and an Aladdin's lamp. They are 4¾" high and are marked "J. Co." as well as "REAL BRONZE."

A 5¼" high Frankart horseheads bookend.

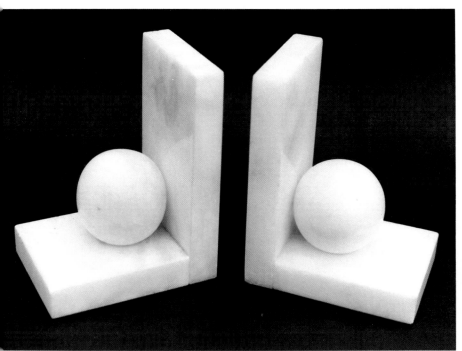

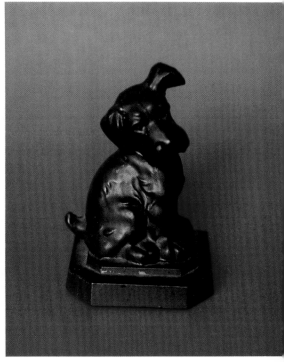

Polished marble bookends, consisting of strong geometric forms, 5¼" high, 4¼" wide.

A 6" high Bronzart stylized dog bookend.

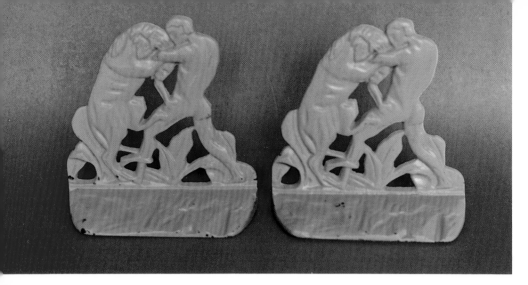

A pair of 5½" high cast iron bookends depicting a geometrized scene of a man fighting a lion. The reverse of these bookends are marked with the pattern, which is "GLADIATOR."

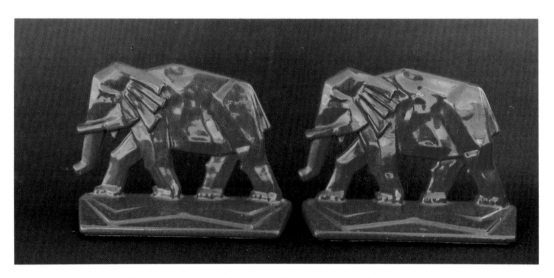

Geometrized elephant bookends with red enamel over cast iron, 5" high, 7" long.

A 6" high pair of Frankart rearing stallion bookends. Cast spelter with a bronze wash.

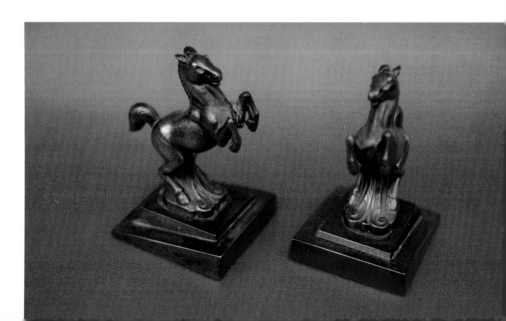

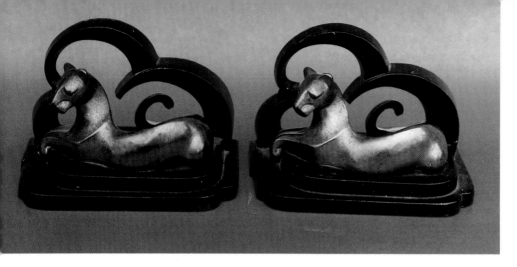

Frankart reclining panther bookends, 3¾" high, 6" long.
Cast metal with original black and gold finish.

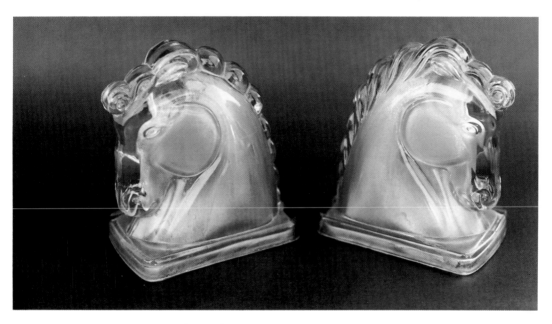

Art Deco design horsehead bookends made from molded
glass, 5½" high.

Art Deco bookends featuring racing dogs made of
bronzed spelter mounted on polished marble bases, 4"
high, 6" long.

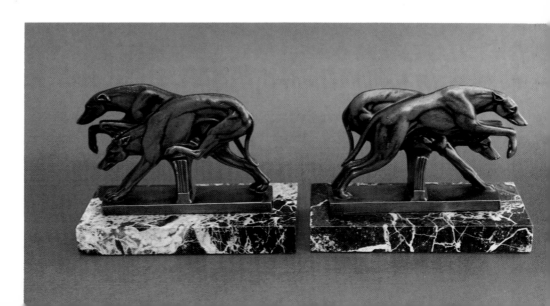

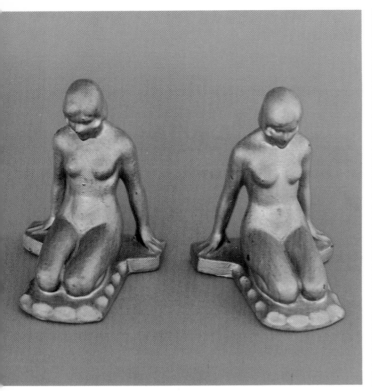

A pair of 5" high cast metal nude bookends.

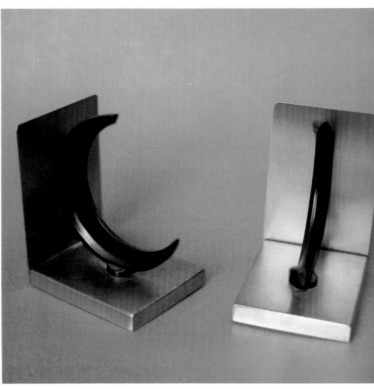

A pair of 4½" high Chase crescent-form bookends made from brass and enameled spelter.

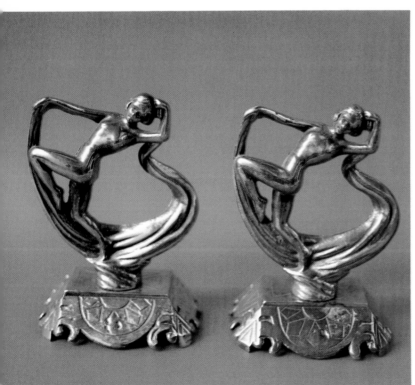

A pair of 7½" high figural bookends made from brass-plated cast iron.

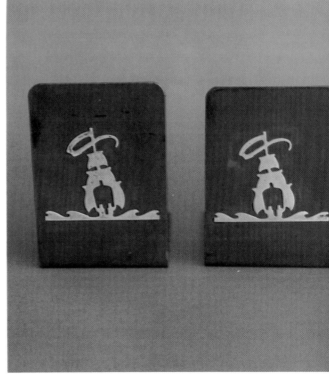

Sterling and bronze Art Deco bookends made by Silvercrest, 4¼" high.

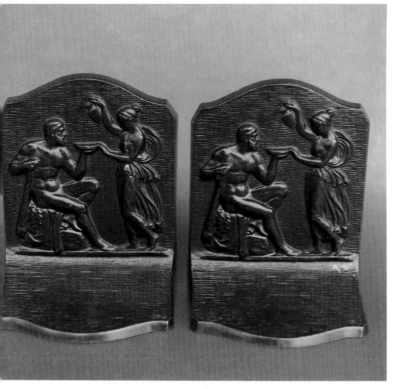

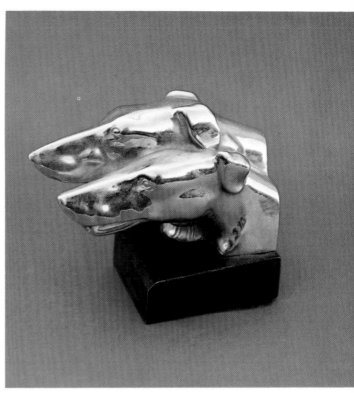

A pair of 6" high Bradley and Hubbard bookends decorated with Classical Greek figures. Cast iron with bronze wash.

A 4½" high chrome greyhound bookend.

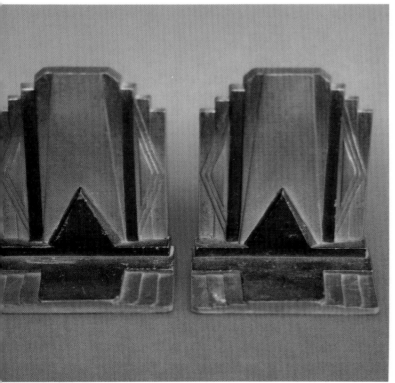

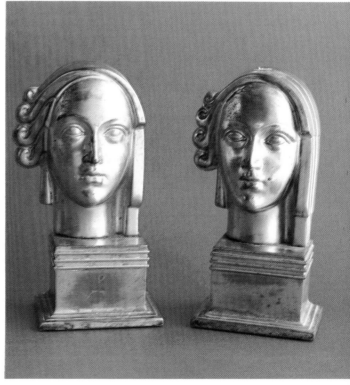

Bradley and Hubbard cast iron bookends highlighted with vivid geometric forms, 5½" high and 5" wide.

A pair of 6½" high gilt spelter bookends displaying strong stylization.

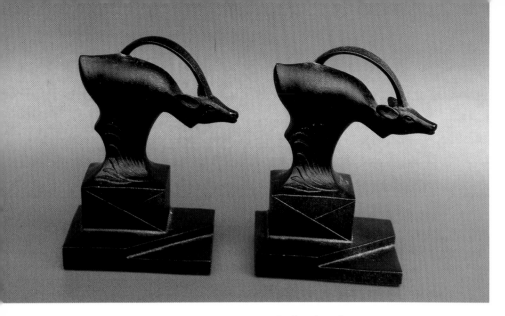

A 6″ high pair of Frankart stylized gazelle bookends.

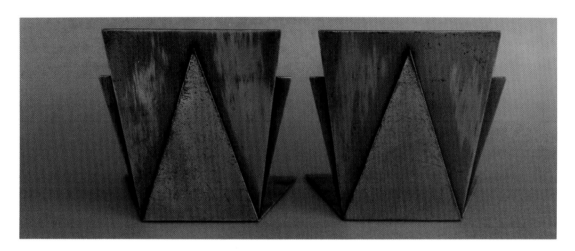

A pair of 5″ high Roycroft copper bookends with geometric brass onlays.

A pair of 5¾″ high Chase bookends of futuristic design. Constructed from copper that has been chrome-plated and enameled with black paint.

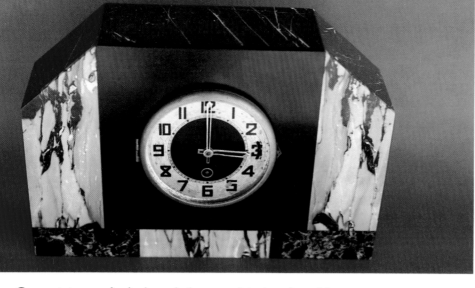

Geometric mantle clock made from multicolored marble, 9" high, 13" long.

Rectangular mantle clock made from polished exotic marble, atop of which is mounted an enameled bronze figure of a flapper. Overall height is 13", length is 13½". The clock is marked "Sarlagou, Narbonne."

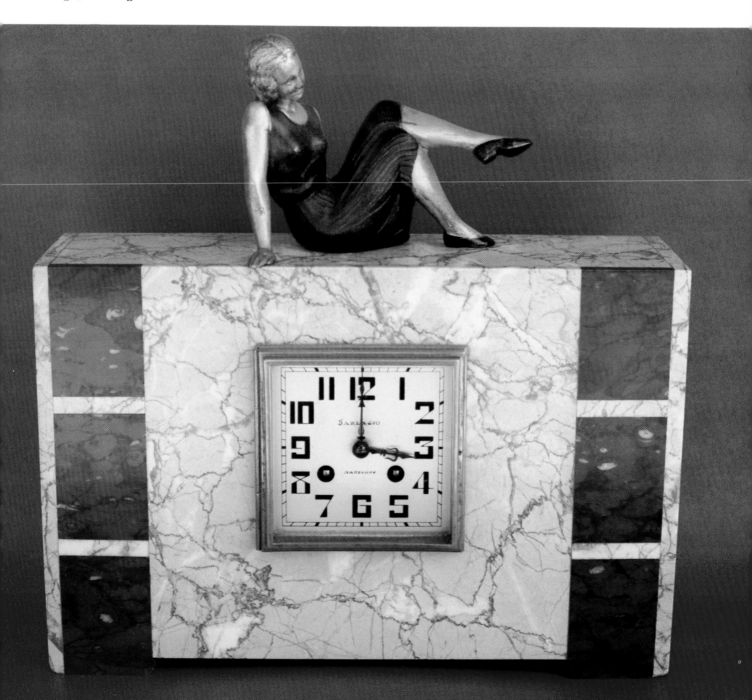

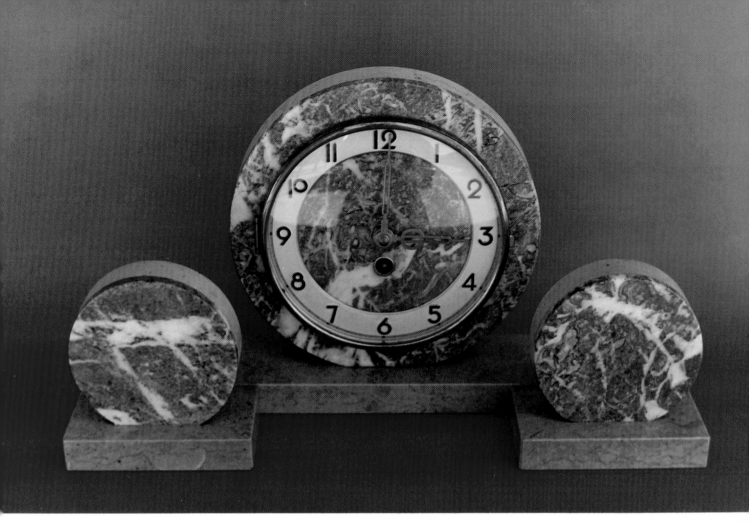

Circular mantle clock (12″ long, 8½″ high) and decorative side pieces (each 4½″ long, 4¾″ high), made from highly polished fossiliferous limestone and exotic marble.

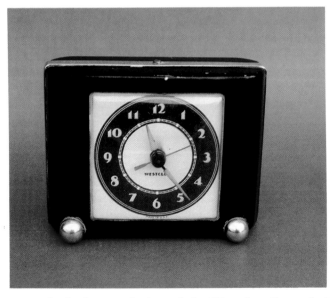

A 4¼″ high electric clock made by Westclox. Enameled metal with polished chrome highlights.

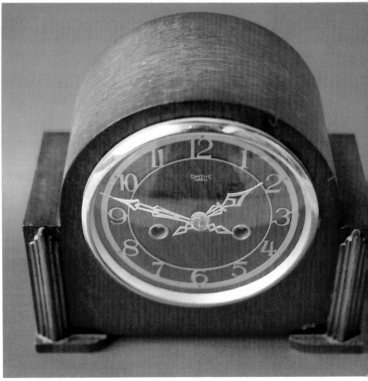

Oak mantle clock with circular face and applied geometric motifs on case, 8½″ high, 9½″ wide. Clock face is marked "Smiths, Enfield."

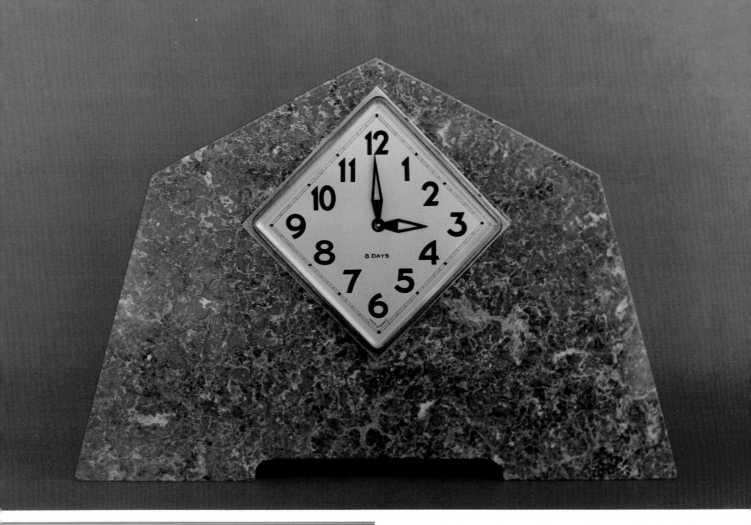

An 8½" high, 13" long 8-day marble mantle clock. It is marked "MADE IN FRANCE."

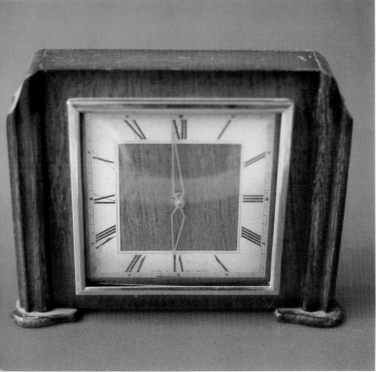

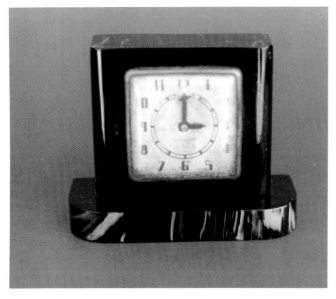

Shelf or mantle clock with square face and stylized rectilinear oak case, 7½" high, 9" wide. Clock is marked "Made in Great Britain."

This 4" high, 5" wide clock is marked "Genuine Catalin" and is patent dated October 1925.

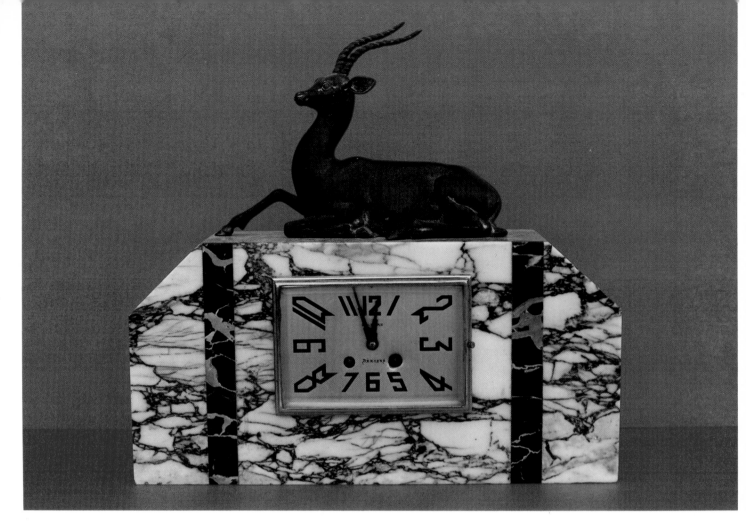

Marble Art Deco mantle clock with decorative cast metal gazelle mounted on the top. Note the stylized numbers on the clock face. Overall height is 14½", length is 16".

Pentagonal mantle clock constructed from polished contrasting marble, the design of which gives a vivid geometric appearance. Dimensions are 8" high and 18" long. The clock face is marked "Made in France."

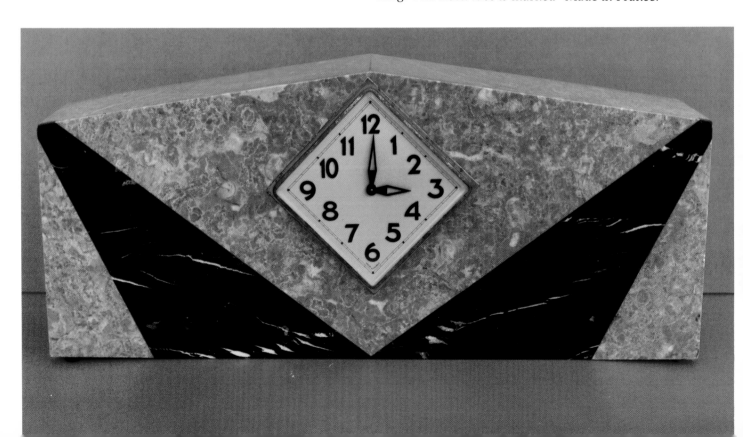

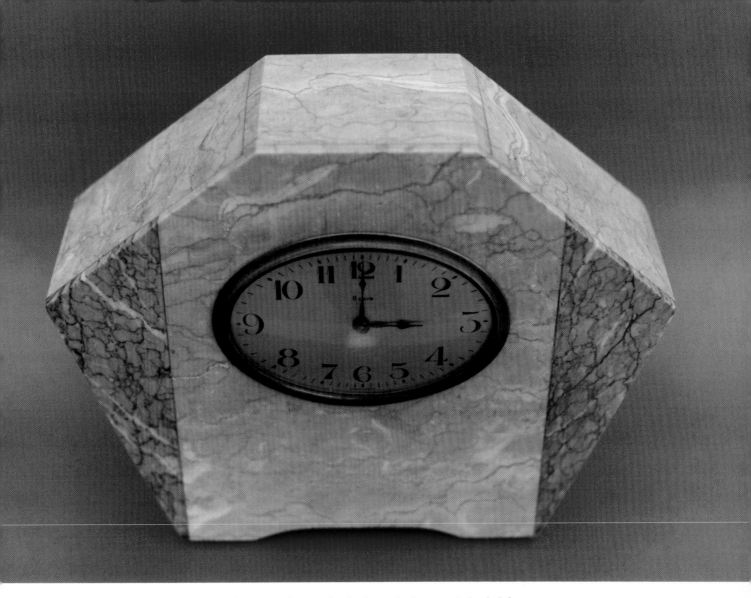

An 8-day French mantle clock made from polished slabs of marble, 9¼" high, 11¼" long.

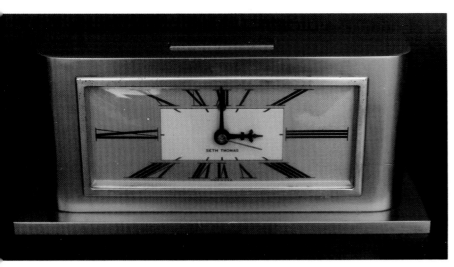

A 4½" high, 10¼" long Silvercrest electric clock. Polished bronze case, Seth Thomas works.

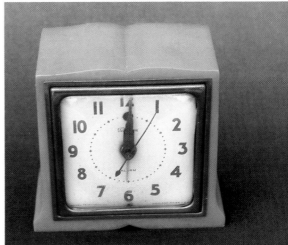

Bakelite electric clock with Telechron works, 4½" high, 4½" wide.

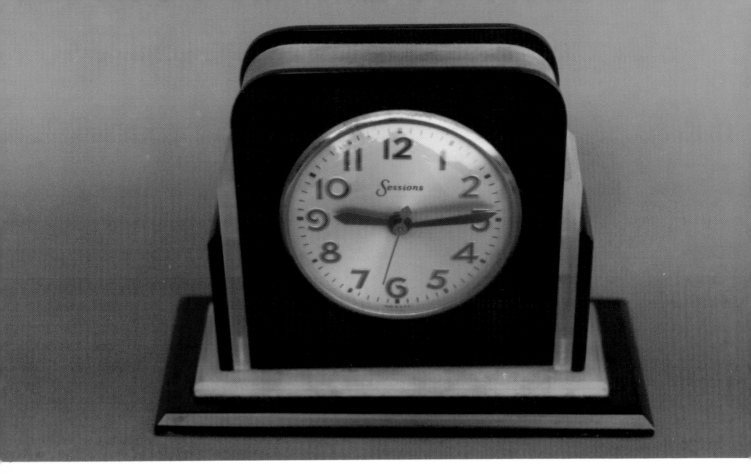

Black and white plastic Sessions electric clock, 6½" high,
9" long.

Celluloid clocks of various designs, 3¼" to 4½" high.

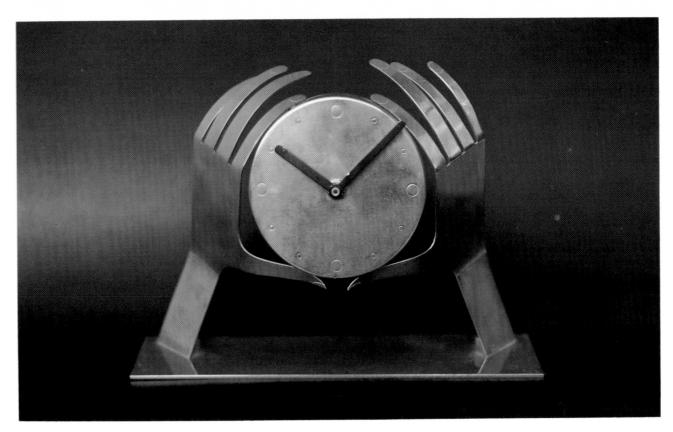

This phenomenal clock was designed and made by Franz Hagenauer of Vienna, Austria. It is 9" high and 12" long.

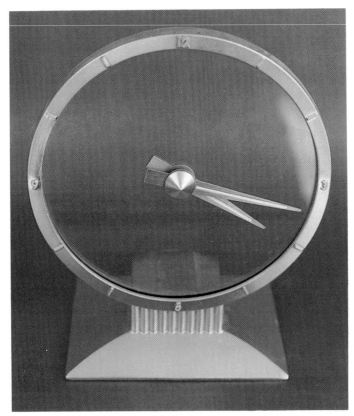

Circular electric clock made from cast metal and glass, 9" high.

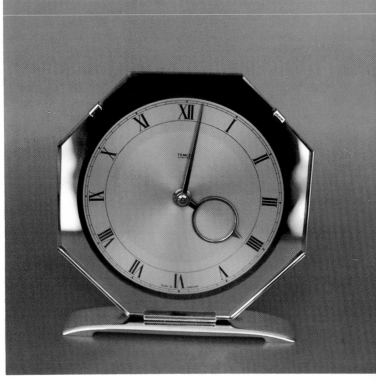

Chrome and pink mirror octagonal electric clock, 7¼" high. The clock face is marked "TEMCO, Made in England."

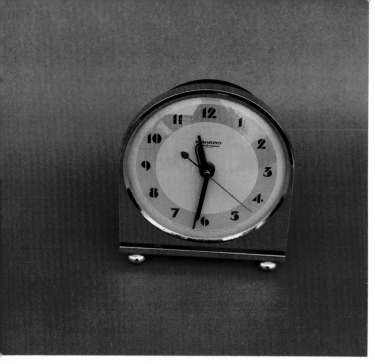

A 5¾" high Hammond Synchronous electric clock with sleek polished chrome and black enamel case and stylized face.

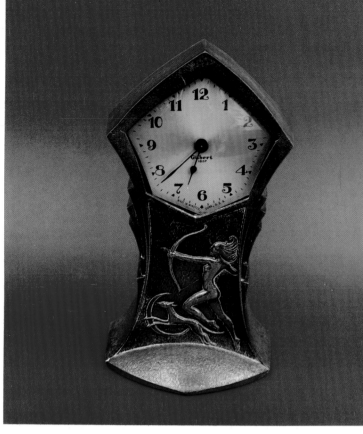

A 9" high spelter Art Deco clock. Gilbert clock works made in Winsted, Connecticut. Note the strongly designed clock case with its geometric angles and embossed stylized figures on the front panel.

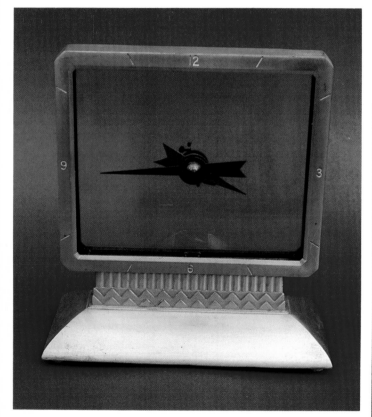

A 9" high electric table clock of geometric form. This type is sometimes referred to as a "mystery clock" because of the glass face, floating hands, and seeming absence of works.

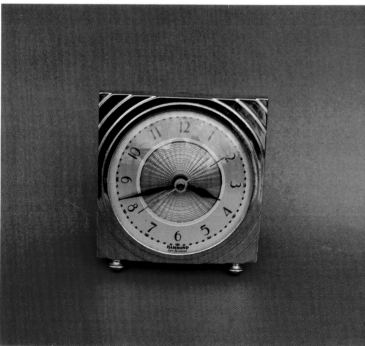

A 5" square Hammond Synchronous electric clock. The clock case is polished chrome with a radiating design.

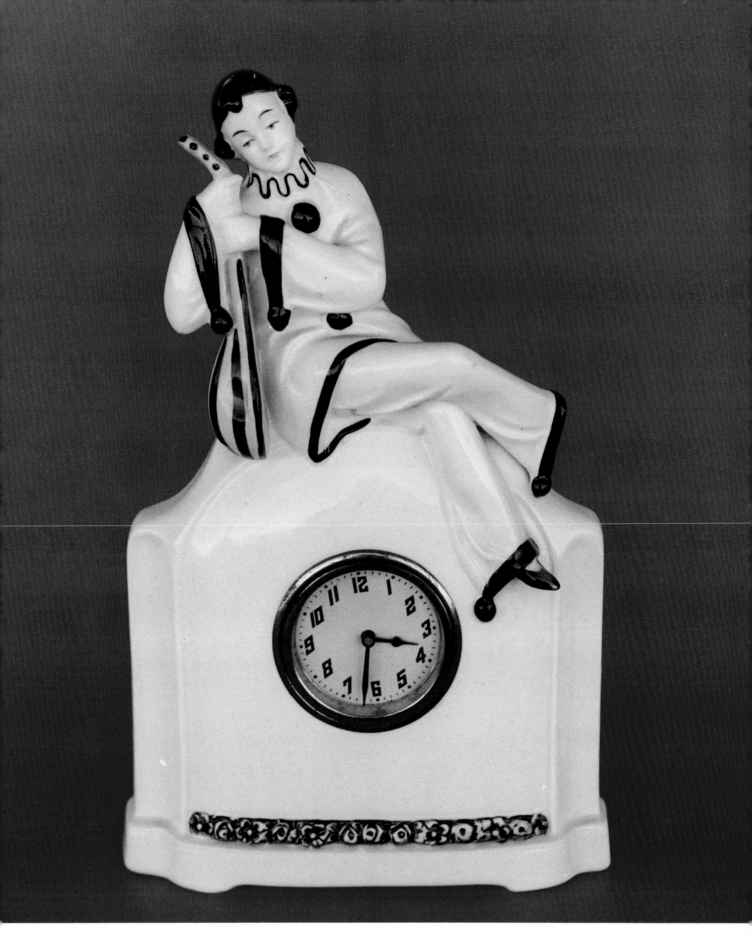

A strongly designed Art Deco ceramic clock, 10½" high.

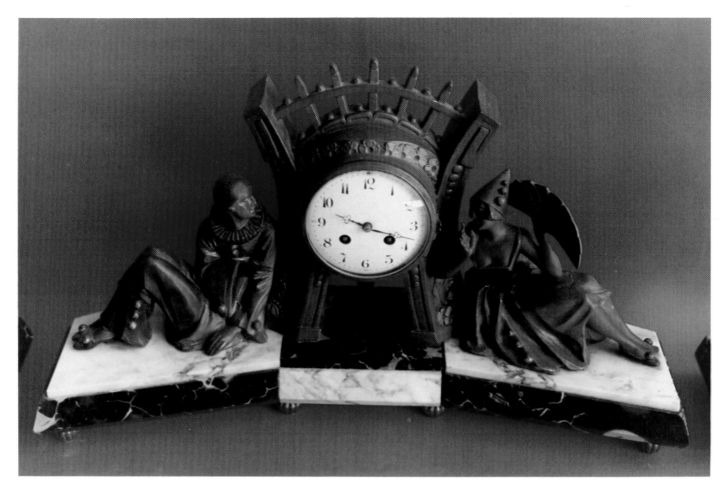

A fabulous French mantle clock made from carved marble and enameled spelter, 13" high and 22" long.

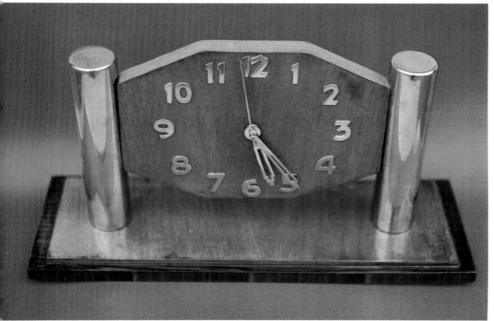

An 8½" high, 18" long chrome and wood Art Deco electric clock. Probably English.

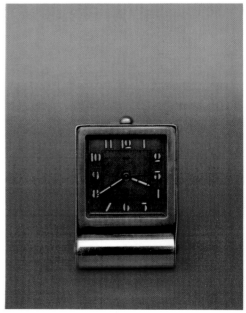

A 3½" high chromed brass traveling alarm clock made by Jaegar of Switzerland.

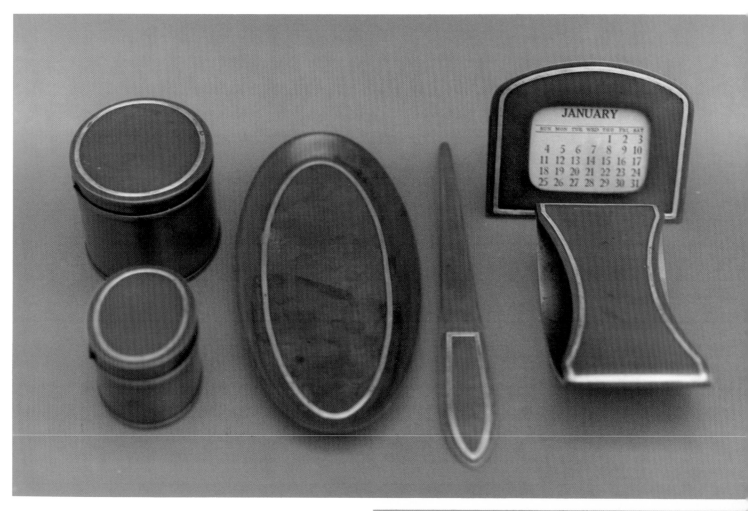

Six-piece Heintz Art Metal bronze and sterling silver desk set.

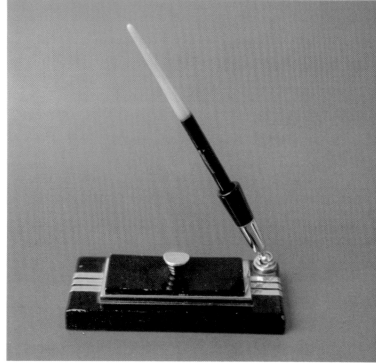

Parker chrome and black enamel desk unit comprised of a pen holder and a lift-out rocker blotter, 6½" long, 3" wide.

Heintz Art Metal letter rack, solid bronze with a bold linear overlay of sterling silver, 5″ high, 9″ long, 3″ wide.

A Grueby pottery scarab form paperweight, 4″ long.

Heintz Art Metal pen tray (9¾″ long) and matching letter opener (9″ long). Note the sterling Art Deco overlay.

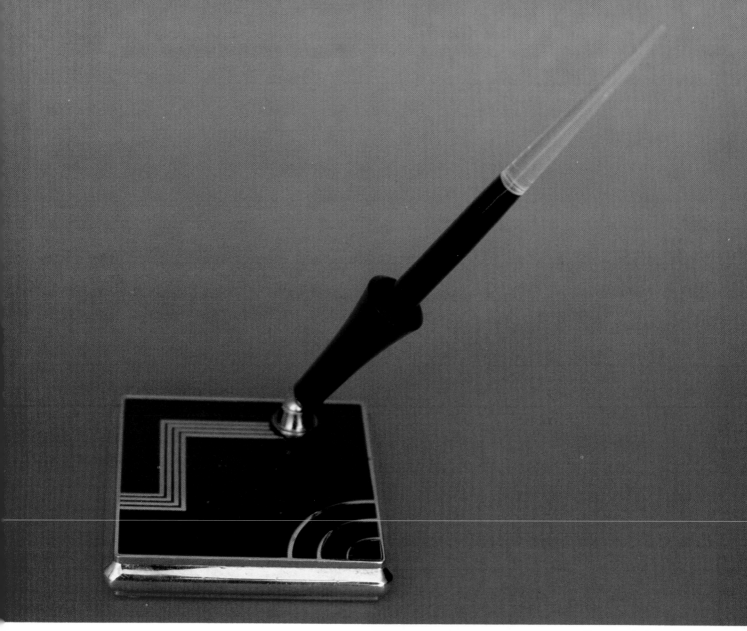

Black enamel and chrome pen holder with geometric decor, 7½" high, 3½" square base.

A Rookwood Pottery lidded inkwell dating from 1923. It is 2¼" high and 4¾" in diameter.

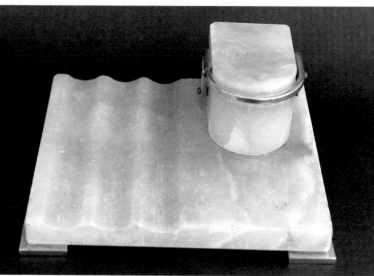

Polished alabaster inkstand with pen grooves and chrome fittings, 3½" high, 8" long, 7" wide.

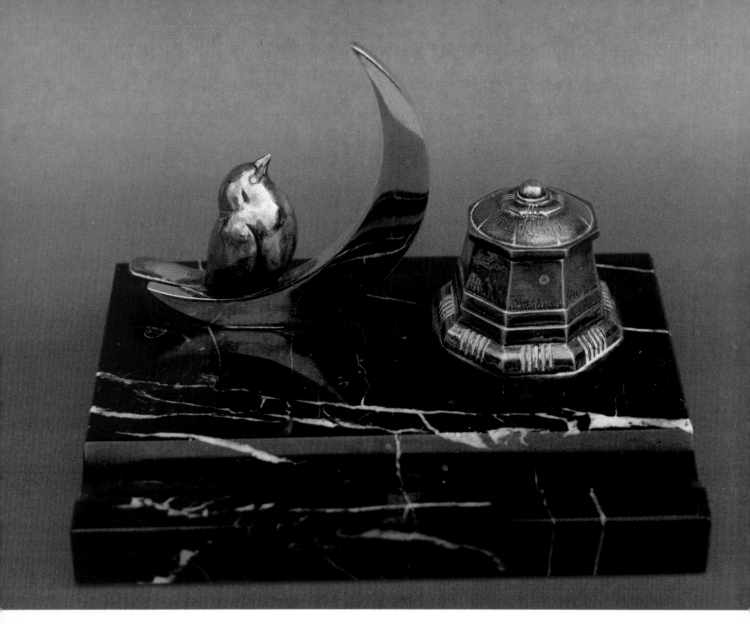

A 4¼" high, 6½" long marble and chromed brass inkwell/pen tray.

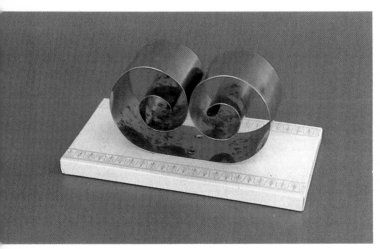

A 3" high, 6" long curled chrome letter holder.

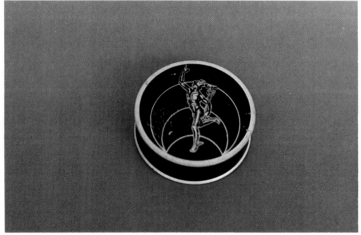

A 2½" diameter Mercury Brand Typewriter Ribbon case.

Silvercrest bronze desk pieces, including a combination letter rack/perpetual calendar (3¾" high, 4" long) and a lidded inkwell (2½" high). Note the linear design work on these items.

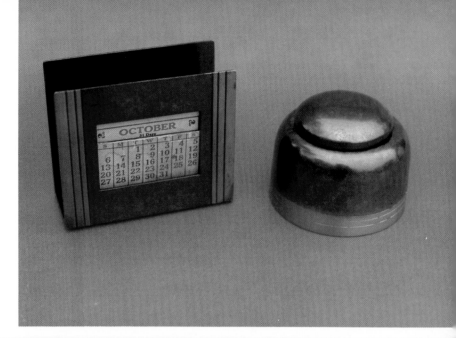

A desktop clock/pen holder made from Bakelite, 8½" high, 10" long.

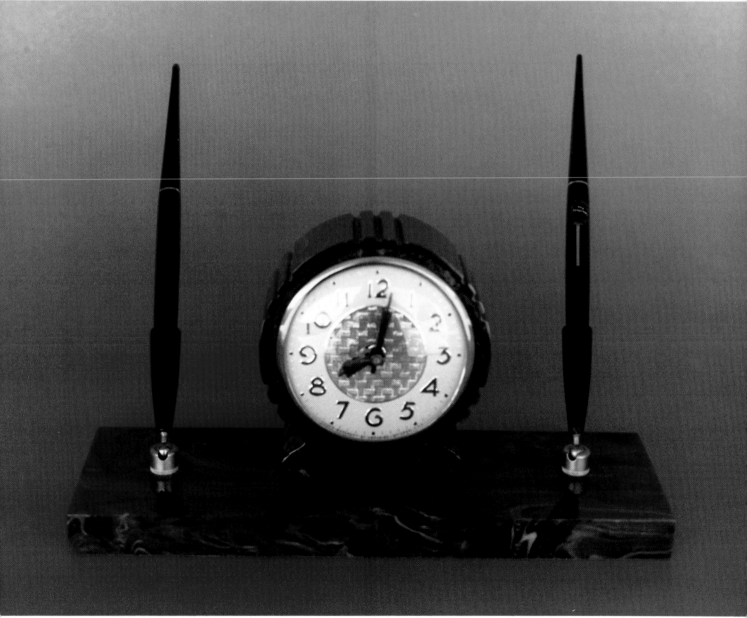

A 9" long Nu Art letter opener with figural handle.

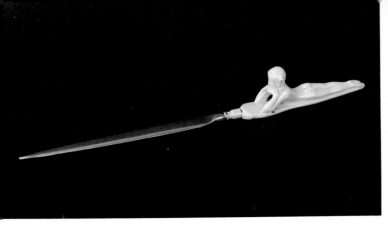

A 3" high Silvercrest perpetual calendar with textured silver-plated over bronze surface and stylized sterling overlay.

A brown Bakelite desk unit that functions as a pen tray, inkwell, and paper clip tray. It measures 3" high, 6¾" long, 6" wide.

A 5" long, 2¼" wide embossed leather ink blotter with a Bakelite knob.

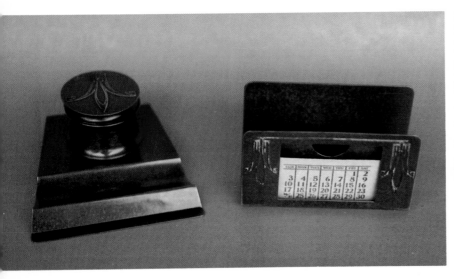

A Heintz two-piece bronze and sterling desk set consisting of a 2½" high inkwell/pen tray and a 3¼" high letter rack/perpetual calendar.

Whimsical Bakelite pencil sharpeners shown in a variety of shapes and colors.

De Vilbiss Art Deco perfume bottles, 4¾" high and 6¼" high.

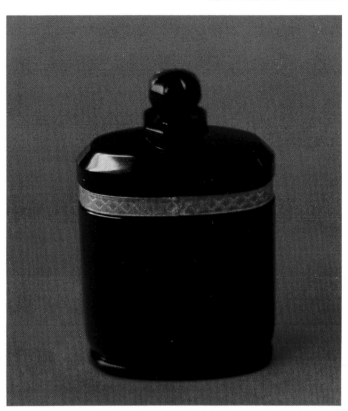

A 3" high black glass perfume bottle with gold band and matching stopper. Probably French.

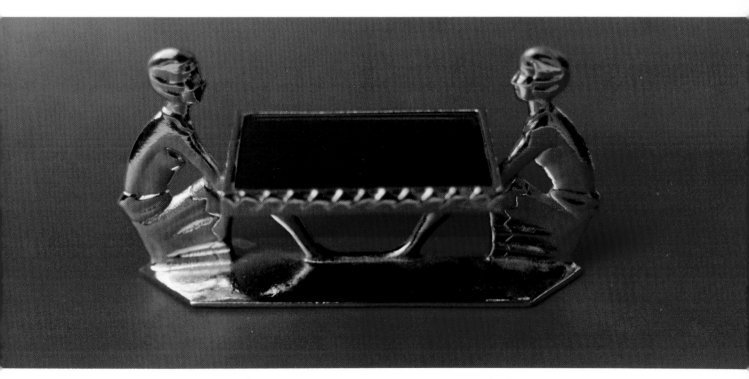

Figural chrome and blue mirror perfume tray, 3½" high, 7¾" long.

A 12″ long Bakelite hair brush with strong Egyptian and linear styling.

Fourteen-inch-long hand mirror embellished with linework and Classical figures. It is marked "Dupont Lucite."

Pink and clear glass perfume bottle with geometric styling, 5¾" high, signed "Czechoslovakia."

A 5" high glass powder jar with female head finial and relief-molded figures on the base panels.

Jewelry box with reverse-painted glass lid featuring a highly stylized floral bouquet, 3½" high, 9" long, and 7" wide.

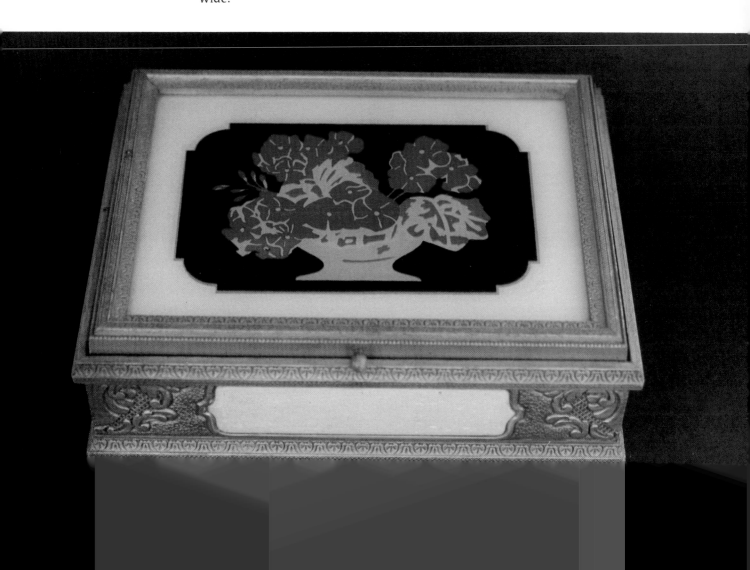

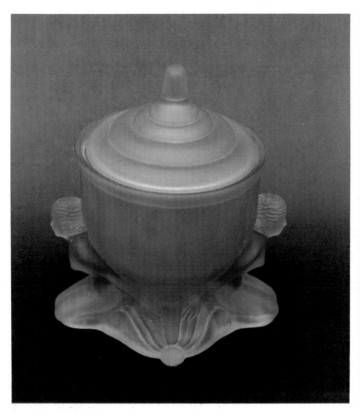

Frosted glass powder jar with figural nudes, 7½" high.

An 8" high figural powder jar made from molded glass.

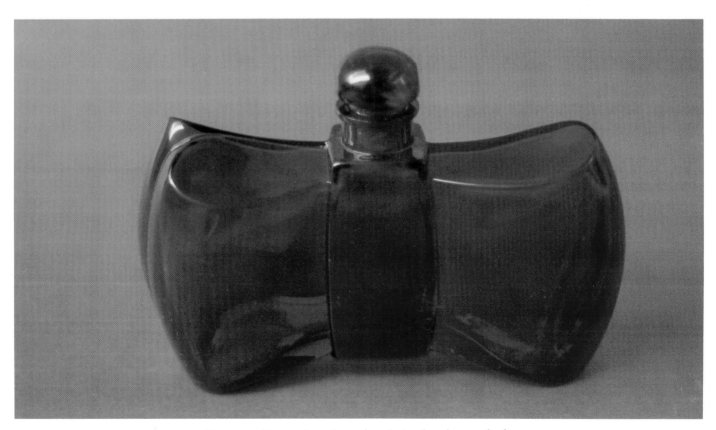

Baccarat (France) perfume bottle in the shape of a bow tie, 4" high, 6" long.

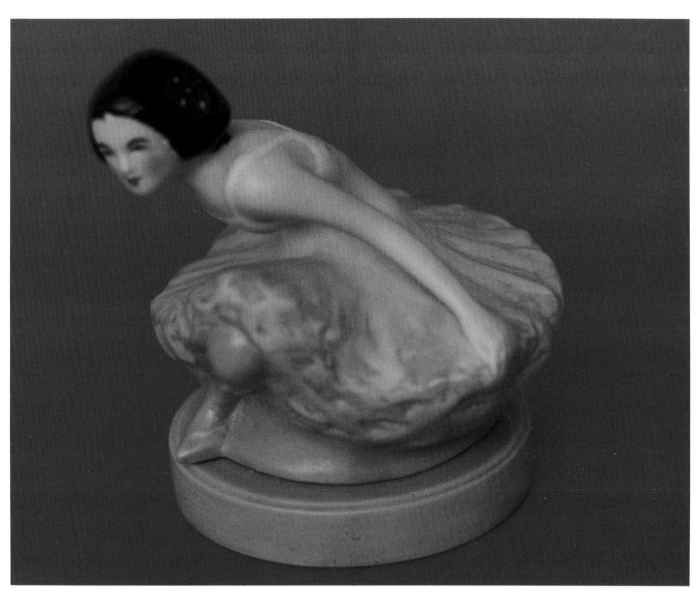

A Fulper Pottery figural perfume lamp, 5½" high.

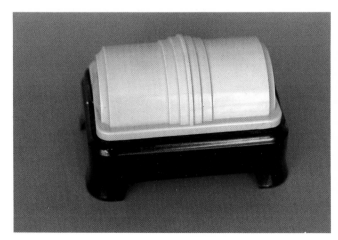

Stylized plastic box containing fingernail products by
Lavall, 4" high, 5½" long.

A 4" high black glass and spelter powder jar with gazelle finial.

Art Deco compacts, including a 7½" long sterling silver example, and a 2½" diameter example with an enameled flapper design on the top.

Composition jewelry box ornamented with colorful geometric forms, 3½" high, 12" long, 8¼" wide.

An 11½" long metal and celluloid hand mirror with conventionalized nature scene.

A grouping of Bakelite-backed clothing brushes. Of special interest is the unusual turtle-form brush.

An enameled brass cosmetic set comprised of powder case, brush, and rouge compact.

A four-piece dresser set consisting of a 10½" long by 7½" wide glass vanity tray, a 12" long celluloid and metal hand mirror, and a pair of 1½" high by 2½" in diameter jars.

A 12" long, 9" wide blue glass dresser tray with chrome fittings and a classical design enameled in the center.

Silvered metal cosmetic container with geometric styling and scotty dog finial, 3¼" high, 3 " in diameter.

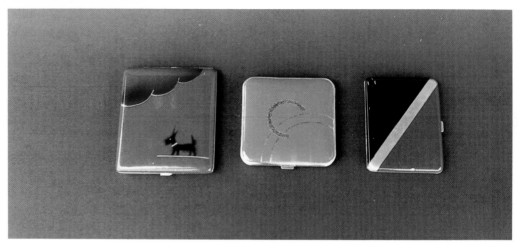

A wonderful assortment of French enameled compacts.

Figurines

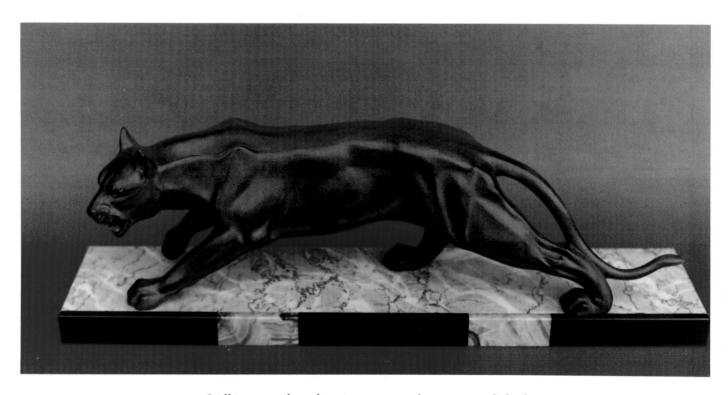

Stalking panther figurine mounted onto a polished marble plinth. The figure itself is cast white metal coated with bronze. Overall length is 21½", overall height is 7½".

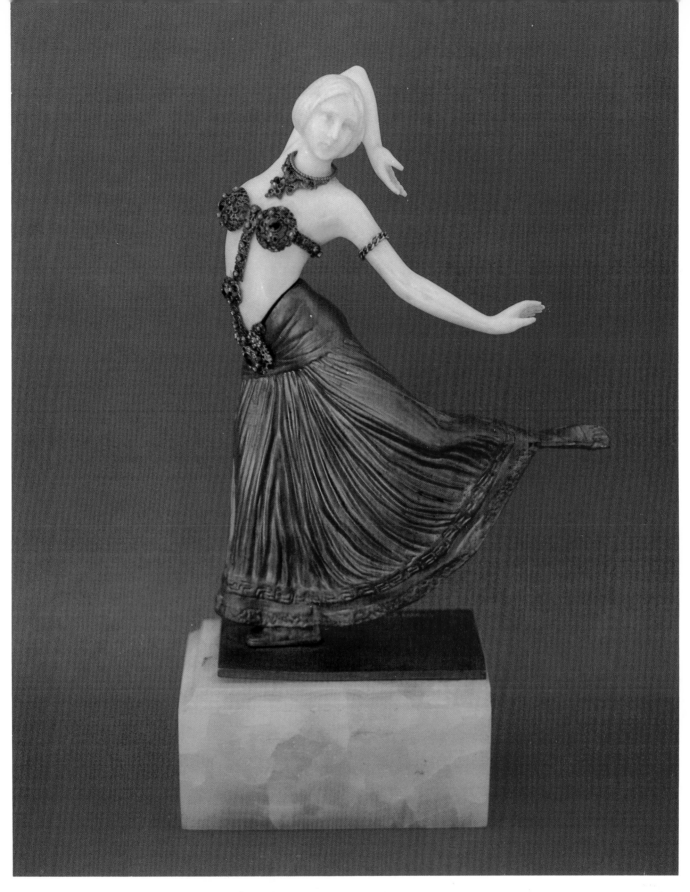

This 9½" elegant figurine is made from a combination of finely carved and polished ivory and cast bronze, which are mounted on a marble base. Signed by the artist, Ullmann.

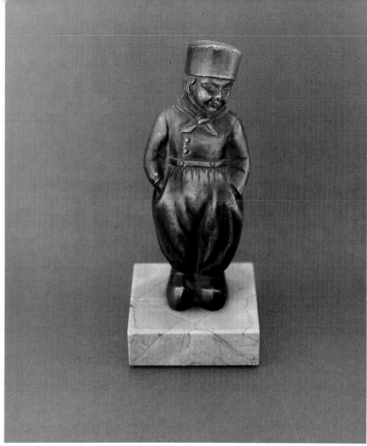

A 5″ high stylized Dutch boy figurine made from bronzed spelter.

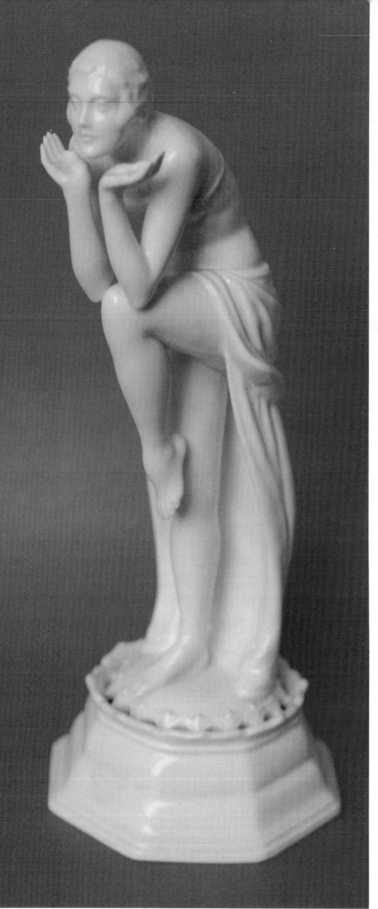

A 11¾″ high Rosenthal figurine/flower frog made from exquisitely detailed porcelain.

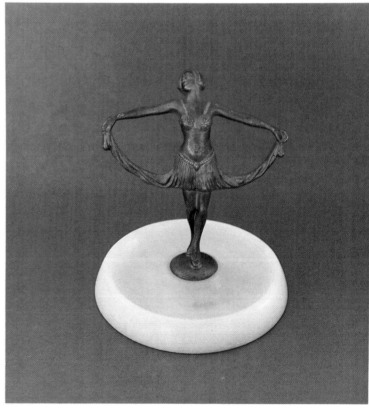

A 7″ high brass figurine mounted on a marble base.

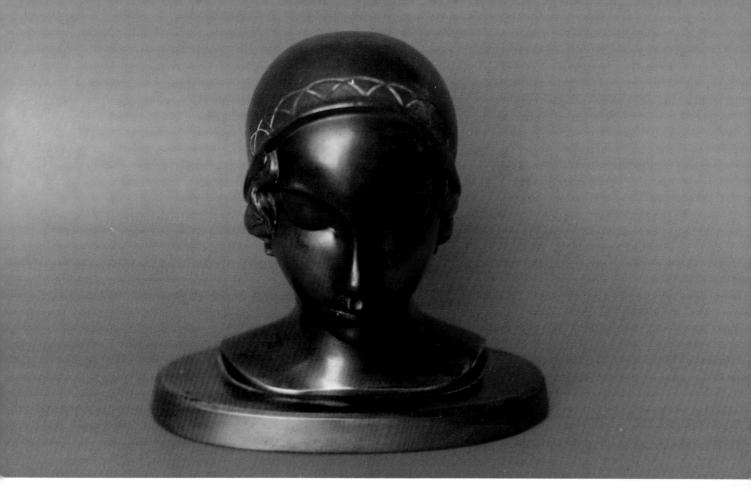

A 7" high Frankart cast metal bust. This is a classic example of Art Deco.

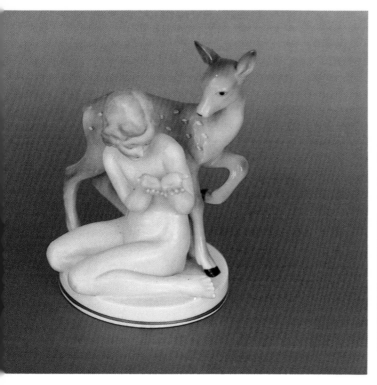

A 6½" high fine porcelain figurine.

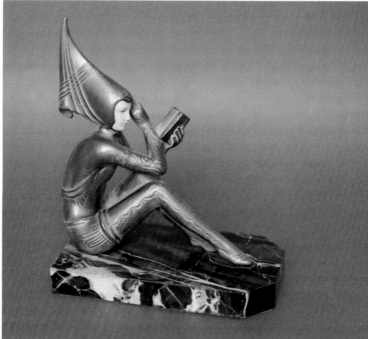

Art Deco figurine made from bronzed metal and mounted onto a polished marble base, 7" high and 6¼" long. The figurine's face is faux ivory.

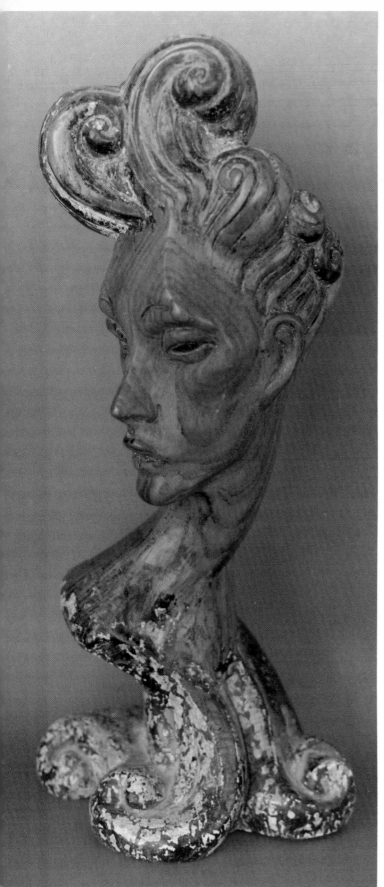

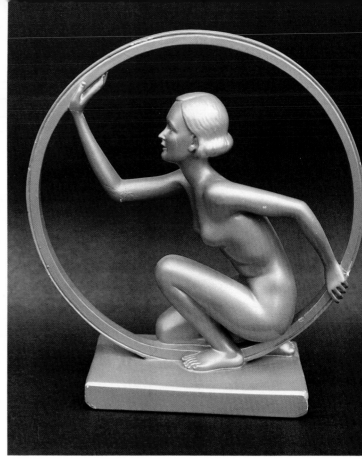

A 12" high chalkware figurine incorporating classic Art Deco motifs: a nude woman and geometric forms.

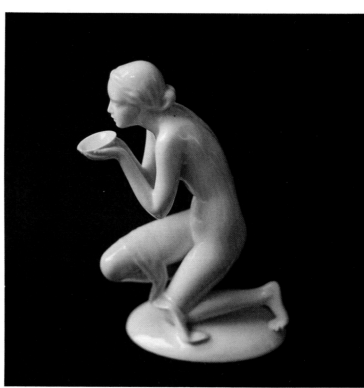

An elegantly executed Art Deco wood sculpture with traces of the original paint, 18" high.

An 8" high porcelain figurine. Base is marked "Marken Hammer." Made in Austria.

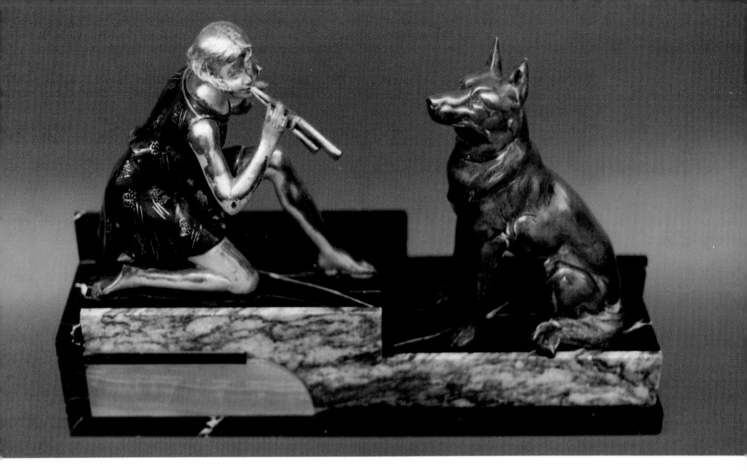

Art Deco figurine made from enameled spelter, which is attached to an exotic marble base. Dimensions are 11½" high, 16½" long.

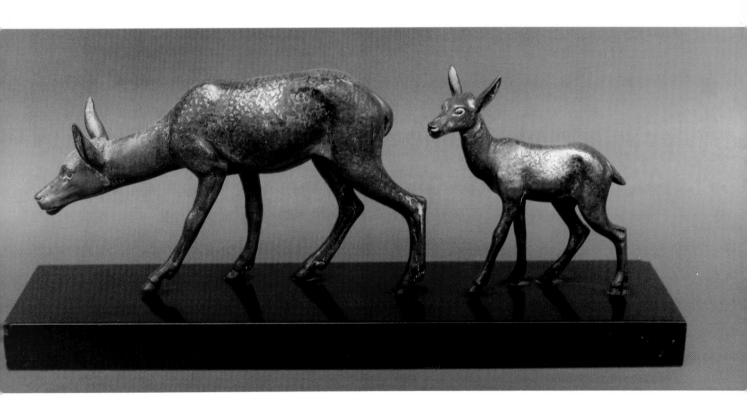

Bronzed metal deer figurine on polished marble base, 7" high, 16" long.

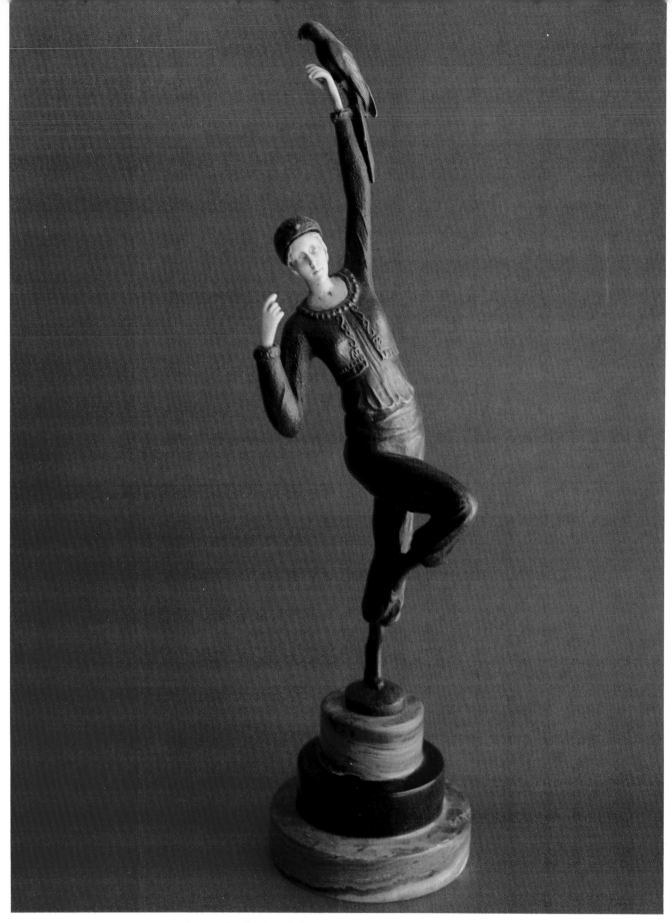

A 15½" high French bronze falconer figurine, signed by the artist, D. Philippe.

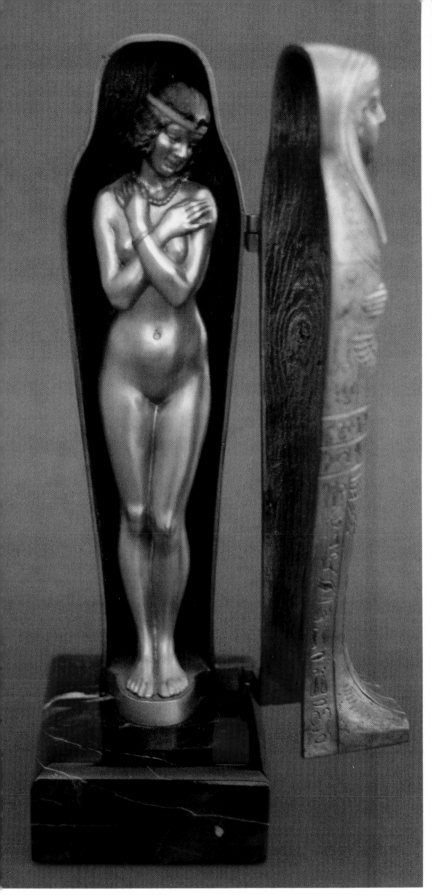
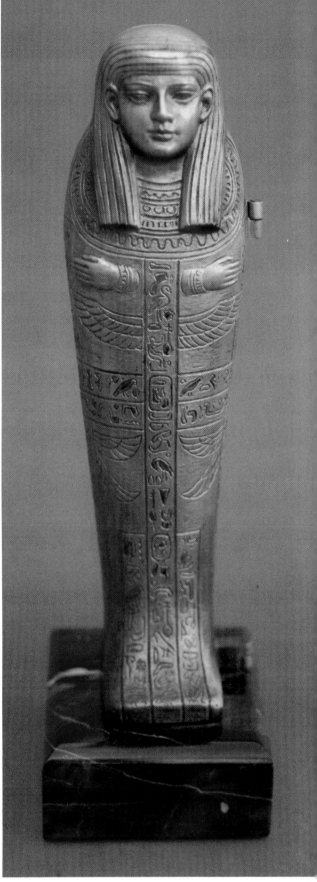

A superb 9½" high cold-painted bronze sarcophagus that hinges open to reveal a nude Egyptian/Deco figure. It is signed by the artist, Nam Creb ("Bercman" backwards).

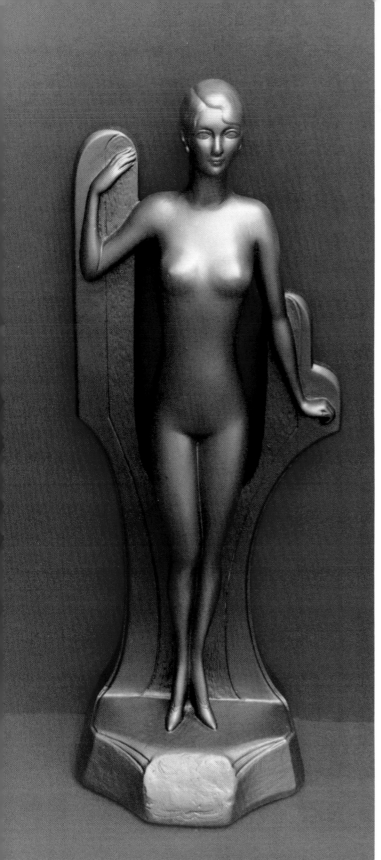

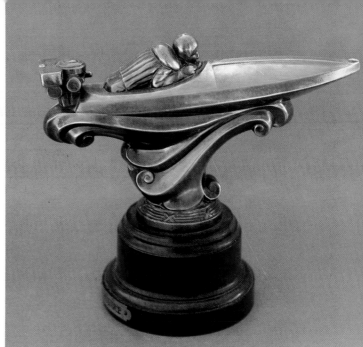

A superbly styled 7½" high cast metal speedboat figurine. This item is marked "Dodge, Inc., LA."

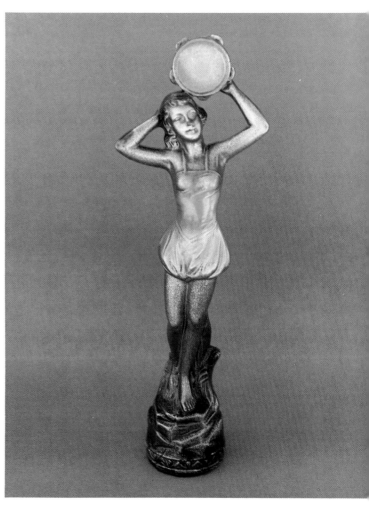

A 22" high painted plaster nude figurine with a stylized cactus in the background. Base is marked "Design in Kraftrock, Rich-Craft Studios, Inc., Jamestown, N.Y." This item is possibly an old window or store display piece.

An 11" high enameled spelter female figurine.

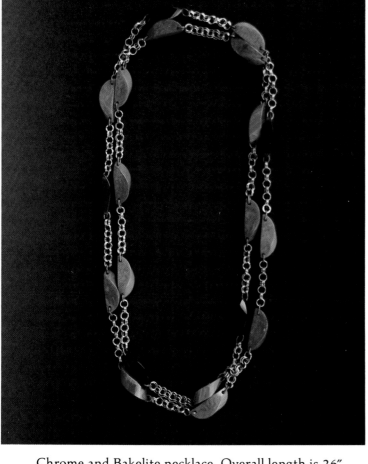

Chrome and Bakelite necklace. Overall length is 26".

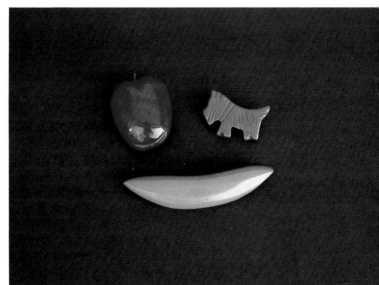

A colorful assortment of Bakelite pins, including a 2" high apple, a 1½" long carved scotty dog, and a 3½" long banana.

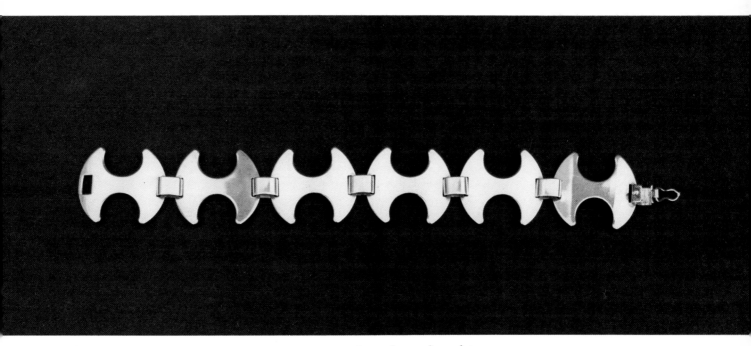

A 7½" long Art Deco design bracelet.

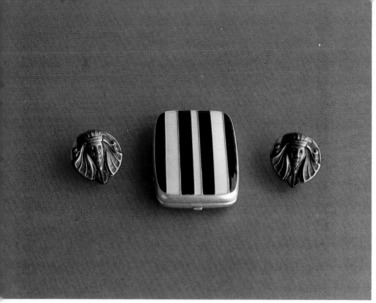

A pair of brass Egyptian style earrings ($20.00—$30.00) and an enameled chrome ring box ($20.00 -$25.00).

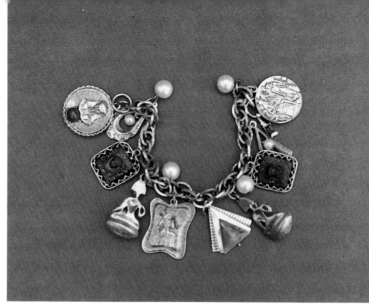

Nickel-silver Egyptian motif bracelet with molded glass sets. Probably Czechoslovakian. Overall length 7″.

A 5¼″ long, 2″ wide catalin buckle.

A pair of green Bakelite bracelets and earrings.

A colorful Bakelite and rhinestone buckle, 1¾″ in diameter.

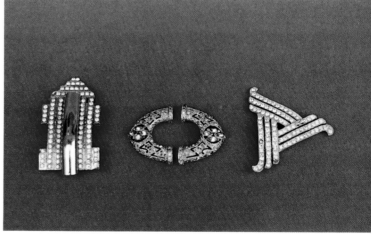

A variety of Art Deco dress clips made from chrome and rhinestones.

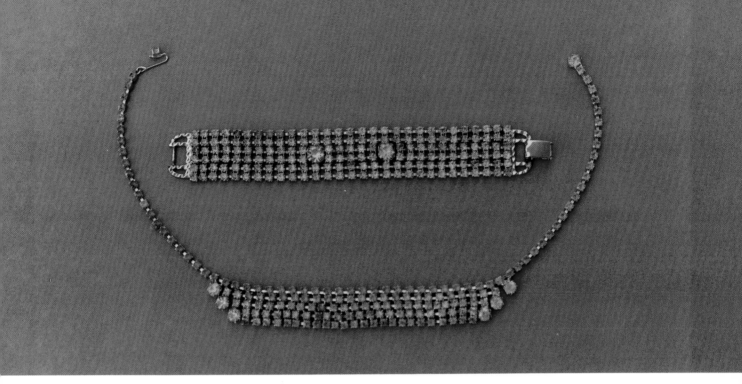

A blue rhinestone necklace with matching bracelet.

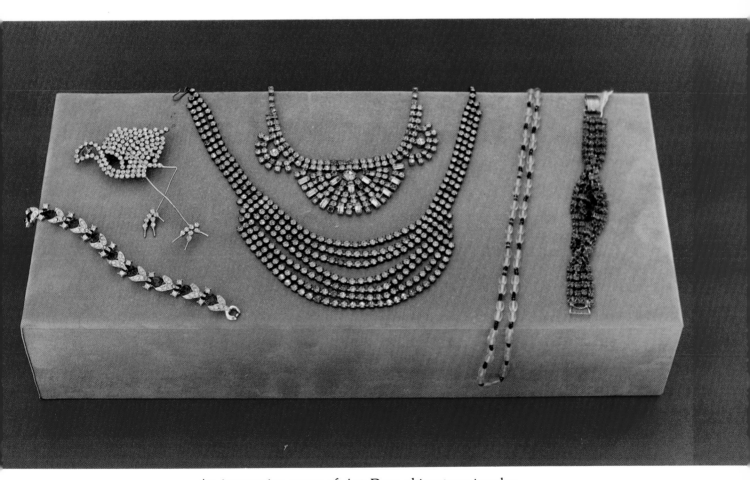

An impressive array of Art Deco rhinestone jewelry,
including bracelets ($25.00—$30.00 each), necklaces
($35.00—$50.00 each) and a pin ($20.00—$25.00).

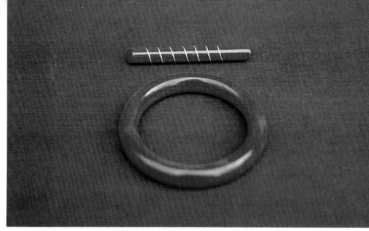

Bakelite pin and bracelet set.

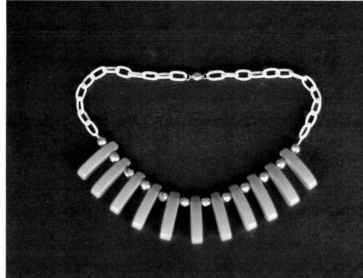

Necklace with carved Bakelite dangles and interspersed chrome beads.

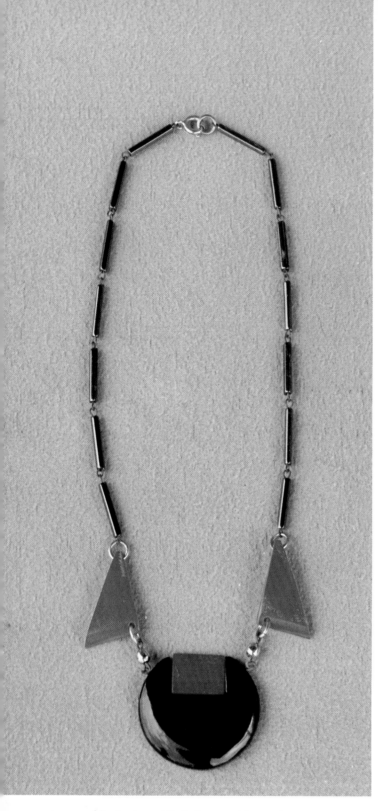

A superbly designed Bakelite necklace of French origin.

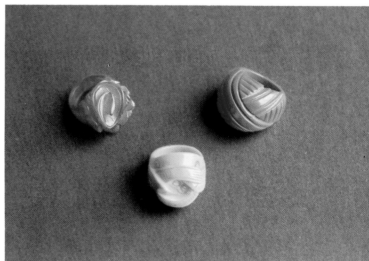

A variety of carved Bakelite finger rings.

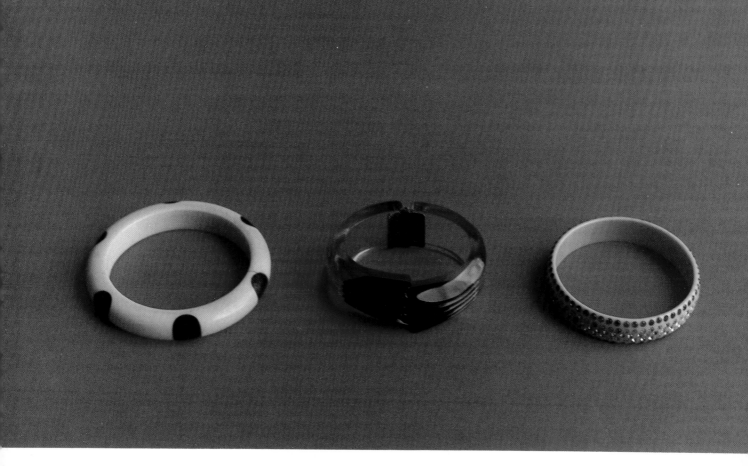

An assortment of collectible plastic bracelets with the polka-dot bangle on the far left being the most desirable.

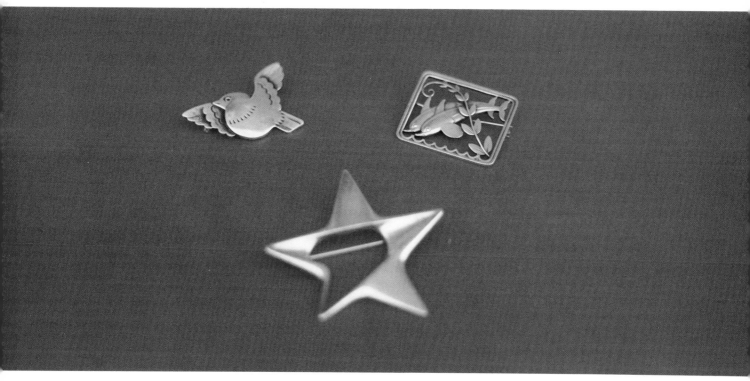

An assortment of Georg Jensen sterling silver pins, all of which reflect Art Deco motifs.

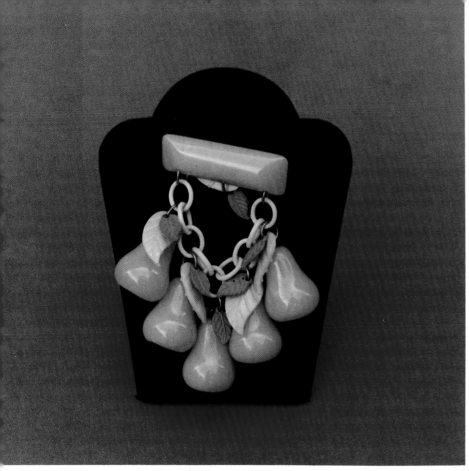

A carved Bakelite pin with pear and leaf dangles.

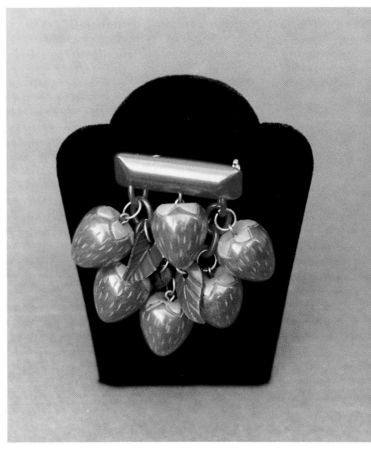

An elaborate carved Bakelite pin comprised of realistic dangling strawberries and leafage.

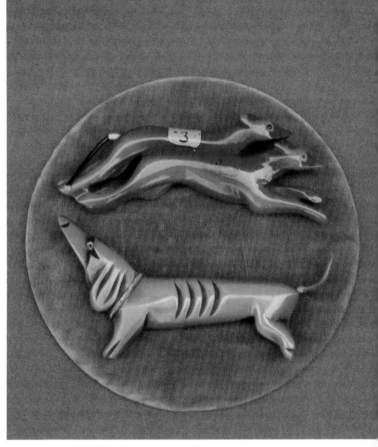

Rare and wonderful carved Bakelite dog pins.

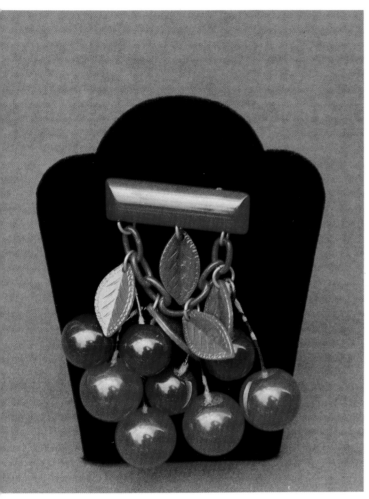

Looking good enough to eat, this carved Bakelite pin features dangling leaves and ripe cherries.

A colorful Bakelite bar pin and an unusual Bakelite heart and stars pin.

A highly carved rectangular Bakelite pin, 3½" long, 2" wide.

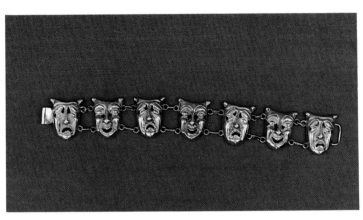

A sterling silver comedy and tragedy masks bracelet.

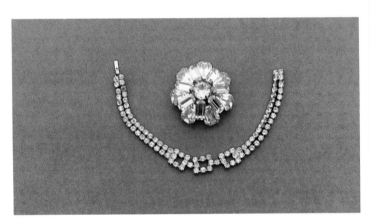

Fine examples of Deco-style rhinestone jewelry, including a large pin and a bracelet.

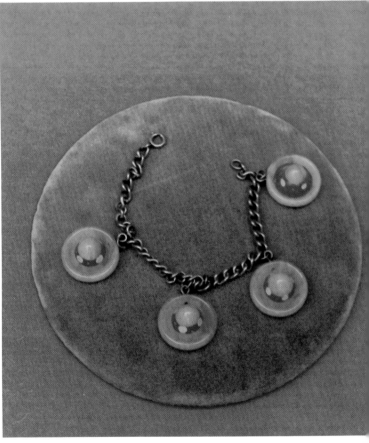

A carved and enameled Bakelite sombrero bracelet.

Bakelite salt and pepper shakers, 1¼" and 1½" high.

Plastic 1939 World's Fair Trylon and Perisphere salt and pepper shakers, 3½" high.

Chrome and Bakelite nut or candy dish, 4¼" high, 7½" diameter. Base is marked "Manning-Bowman & Co., Meriden, Conn."

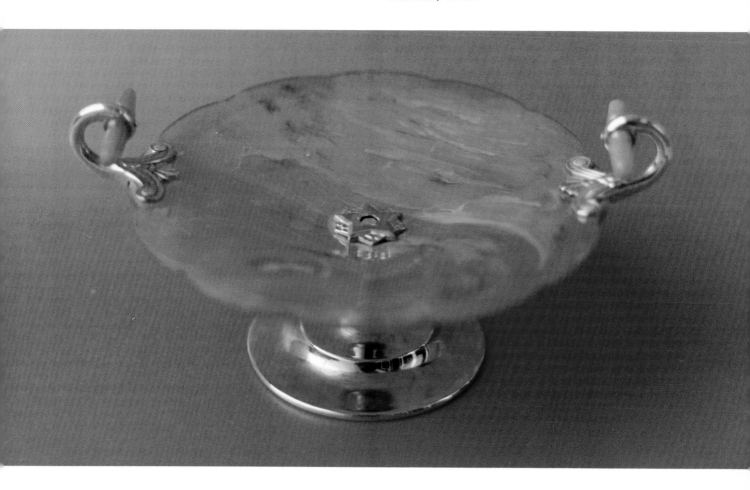

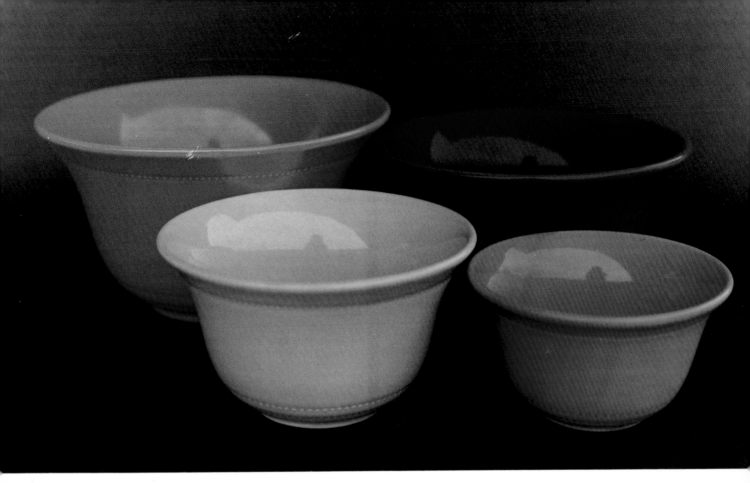

A complete set of the Hall China Company's "Radiant Ware" bowls, 5" to 8½" in diameter.

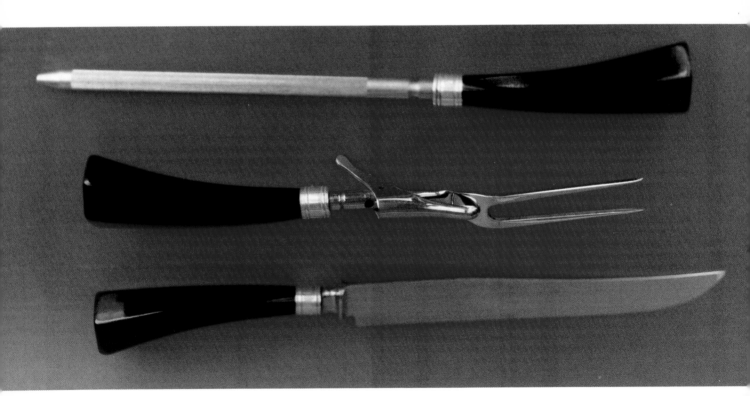

Three-piece carving set. Stainless steel, sterling trim, and Bakelite handles.

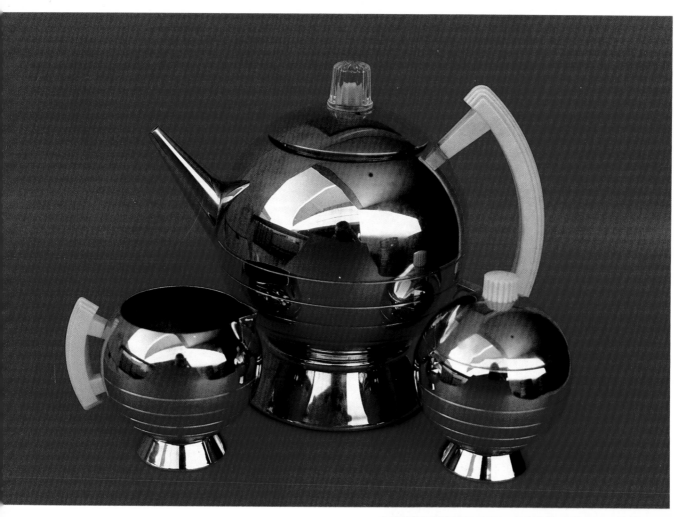

Three-piece Chase coffee, creamer and sugar set made from polished chrome over copper with attached Bakelite handles. The coffee pot is 8½" high.

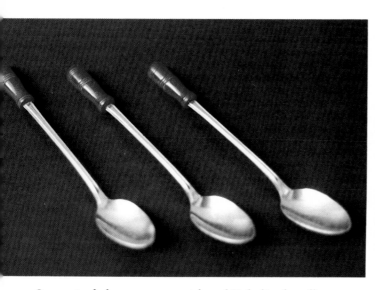

Seven-inch-long spoons with red Bakelite handles.

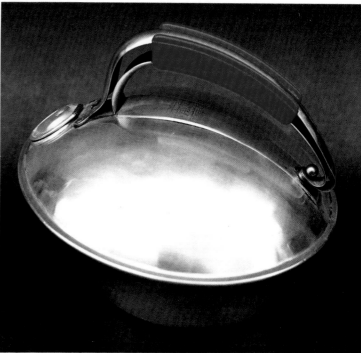

A 7" high aluminum and plastic "EXCEL DELUXE WHISTLING T-KET-L."

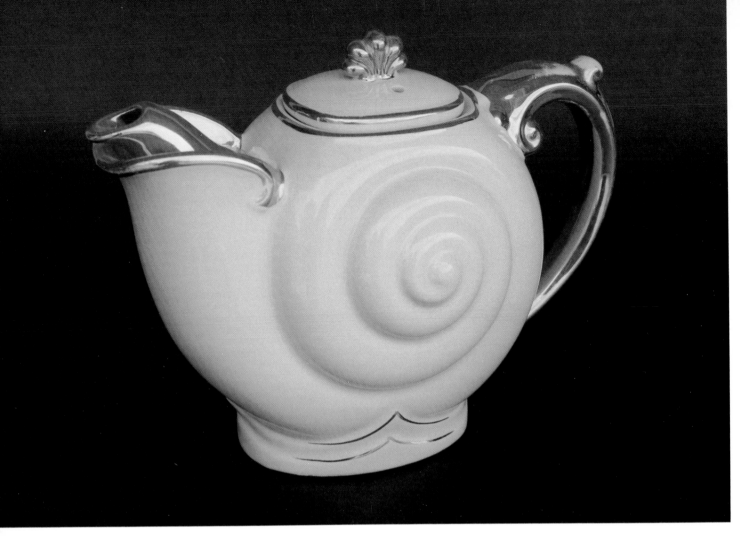

Hall China "Nautilus" teapot, 7" high.

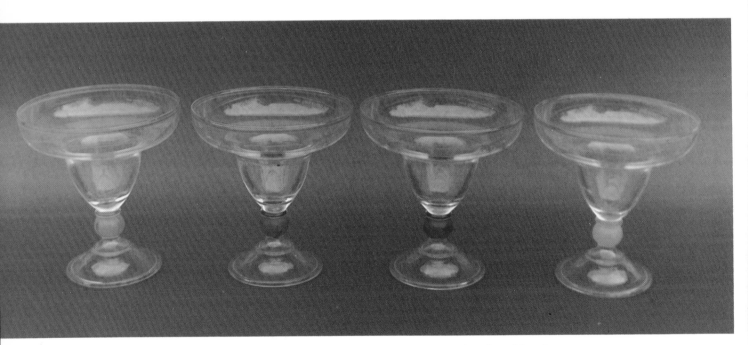

Five-inch high crystal dessert dishes with colored knob
stems.

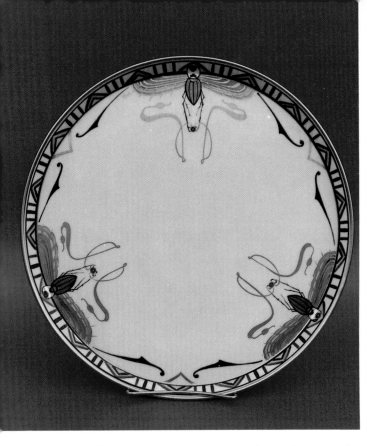

An 11¼" diameter Limoges porcelain plate with American hand-painted scarab decor. This piece is signed by artist M. Bach.

Hall China pie plate with polychrome geometric designs, 10" diameter.

An 11" diameter Bavarian porcelain cake plate with striking black, white, and silver patterning.

A 7½" diameter plate with transfer-printed geometric designs. Made by Albert Pick Co., Chicago, Illinois.

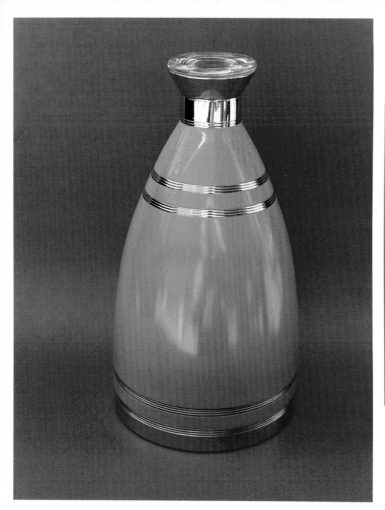

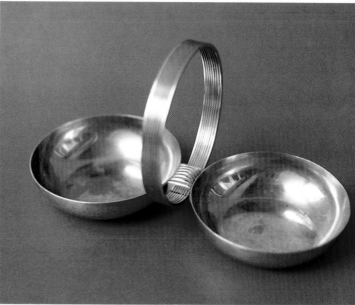

Polished chrome nut or candy dish made by Chase, 5″ high, 8½″ long.

A 9½″ high Art Deco thermos made from chrome, plastic, and glass.

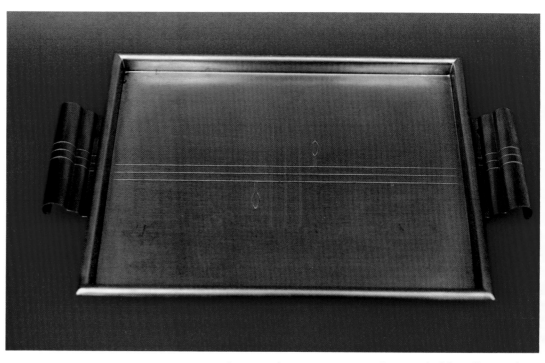

Stainless steel serving tray with rounded handles and incised linework, 15″ long, 9″ wide.

An Art Deco silverware box constructed from painted wood and enameled chrome, 4¼" high, 15" long, 10" wide.

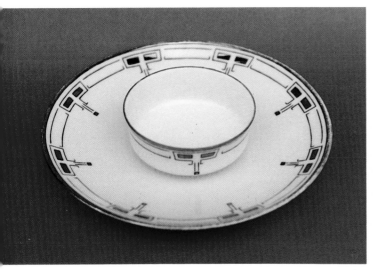

Haviland, France, porcelain plate and bowl set with hand-painted silver Art Deco designs. Plate is 8" in diameter; bowl is 1¼" high, 3" in diameter.

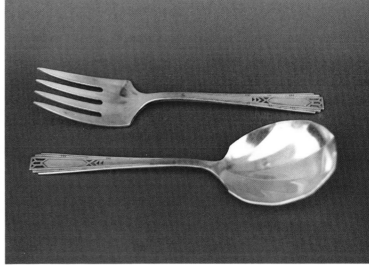

A 9" long Oneida silverplate serving spoon and fork set with Art Deco patterning.

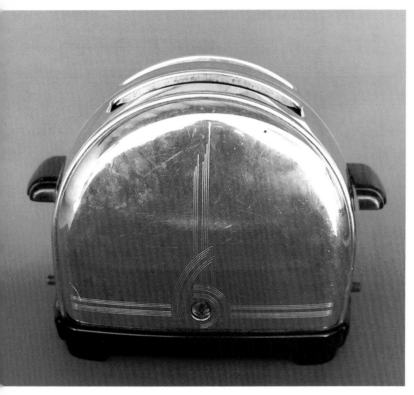

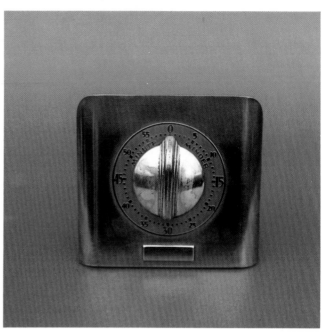

A 4¼″ high Silvercrest polished bronze timer.

A 7½″ high Sunbeam toaster made from chromed metal and plastic.

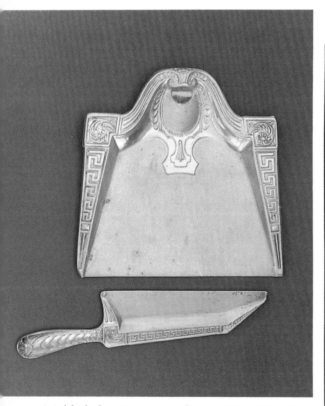

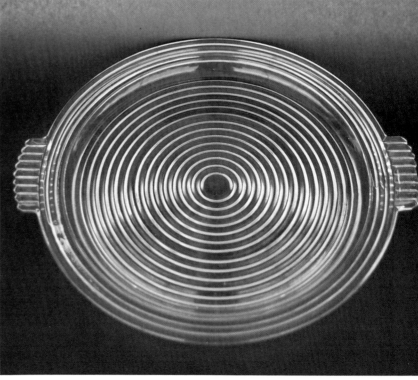

Molded aluminum crumb tray (8″ x 8″) and scraper pan (10″ long) with embossed geometrics.

A 14″ diameter Manhattan depression glass relish tray.

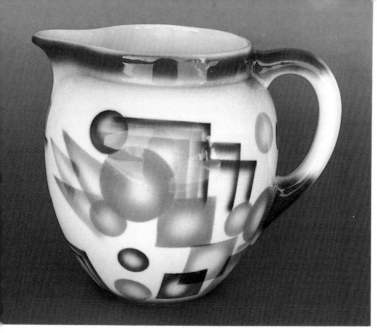

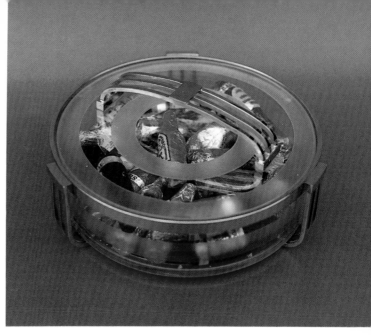

A 6½" high ceramic batter pitcher with underglaze polychrome geometrics. Made in Czechoslovakia.

A 2½" high, 8" wide chrome and etched glass candy dish.

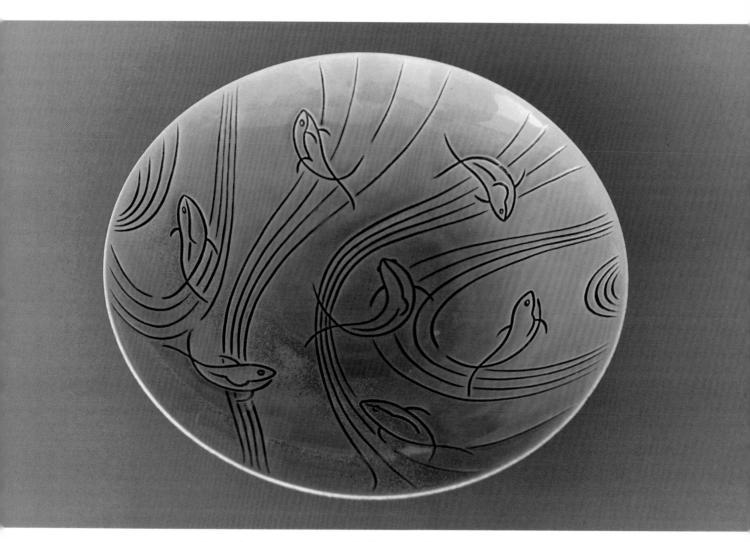

A 14" diameter ceramic salad bowl with swimming fish theme by Roselane.

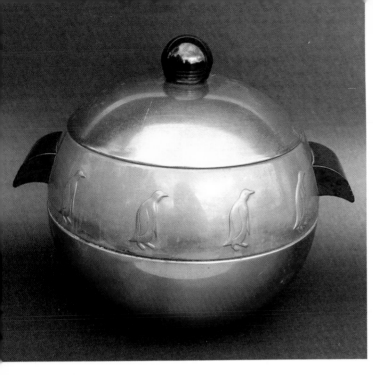

This 8" high hot and cold Penguin server made by West Bend is especially popular with Deco collectors. It can be found in both chromium and copper-plated steel with Bakelite or wood fittings.

A 7½" high Alamo Pottery pitcher incorporating bold geometric designs.

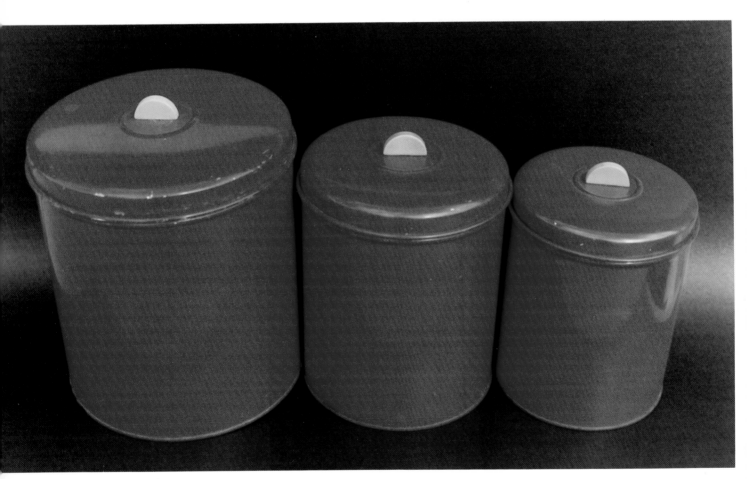

An Art Deco canister set made from brightly painted tin with Bakelite knobs.

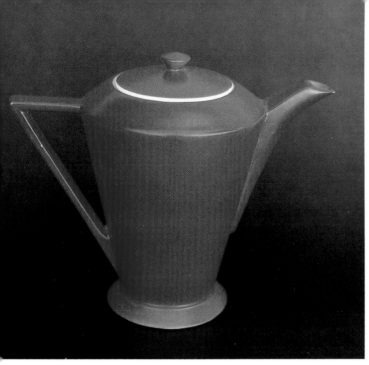

A 7½" high Salem China teapot in the Streamline pattern.

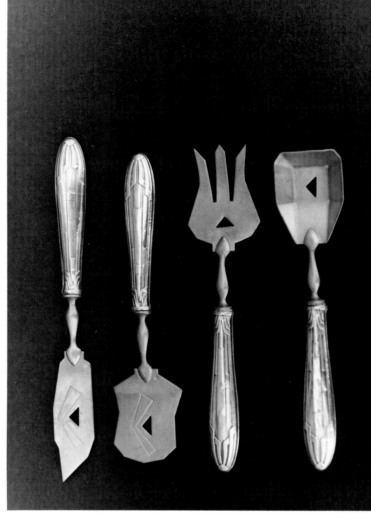

A four-piece sterling and brass serving set incorporating geometric motifs, 6½" to 7½" long.

Bakelite bird-form napkin rings, 2½" high and 3" wide.

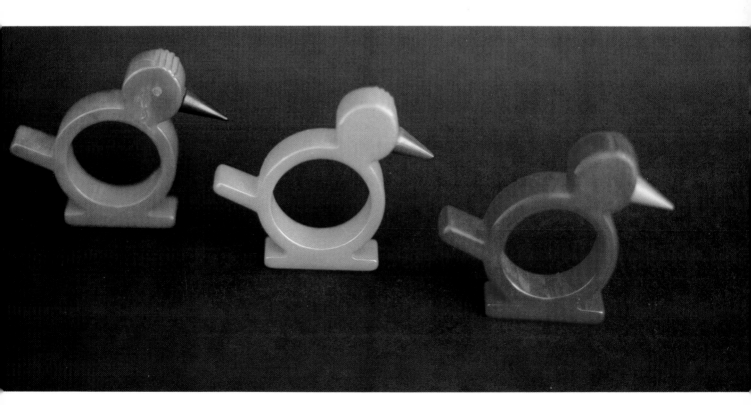

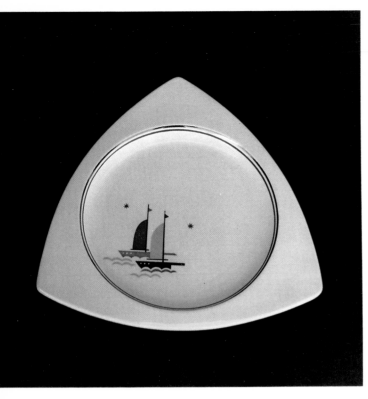

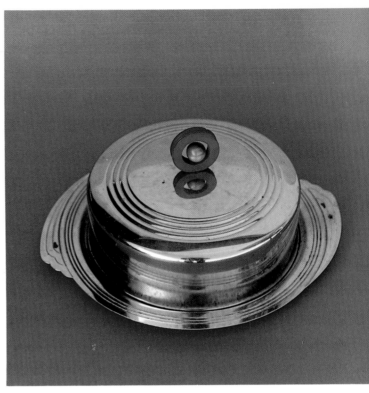

An 11½" diameter plate in the "Tricorne" pattern by the Salem China Company of Salem, Ohio.

A 5" high 10½" diameter chromed metal-covered cake dish with a Bakelite knob.

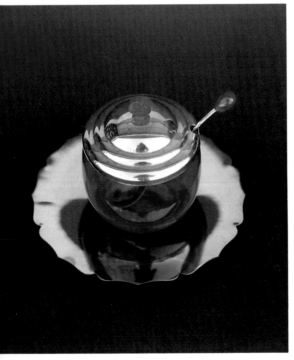

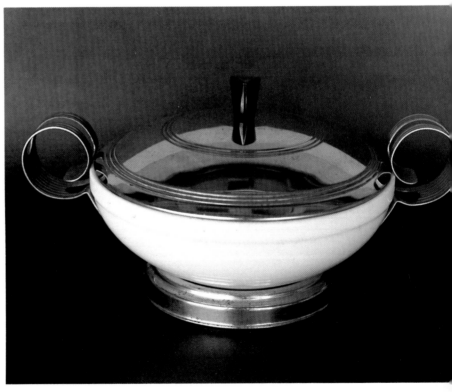

A chrome, red glass, and Bakelite jam jar or sugar bowl. The underplate measures 6½" in diameter, while the overall height is 4½".

A very stylish ceramic and chrome casserole dish, 6" high, 13" overall in diameter.

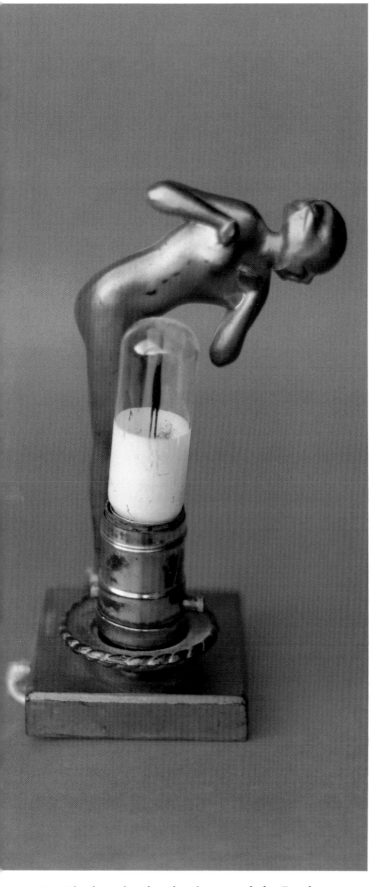

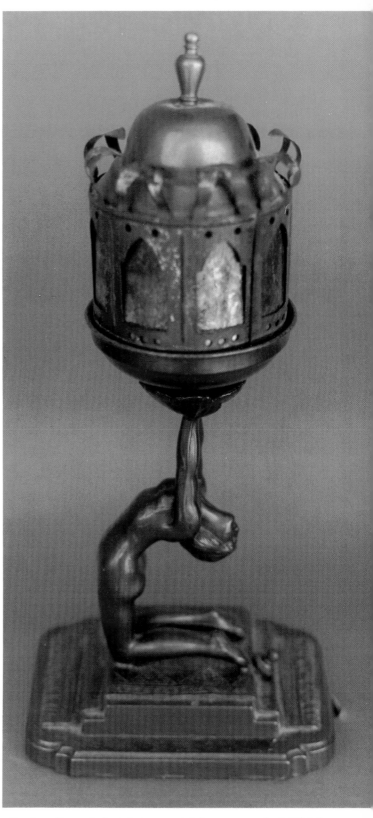

An 8″ high spelter boudoir lamp made by Frankart.

Spelter figural electric lamp with bronze wash, 14″ high. Inset mica panels in shade cover.

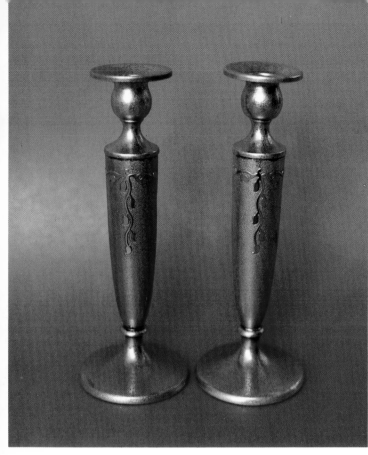

Silvercrest 9½" high bronze candlesticks with acid-etched texturing and gold wash.

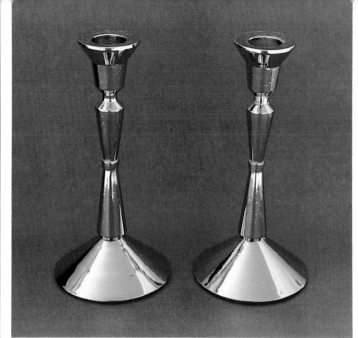

A pair of 6¾" high chromed metal candlesticks.

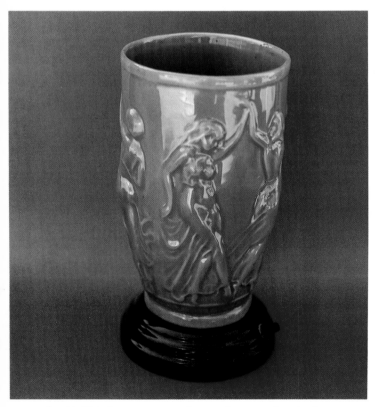

An 8¼" high art pottery electric lamp with relief-molded dancing female figures.

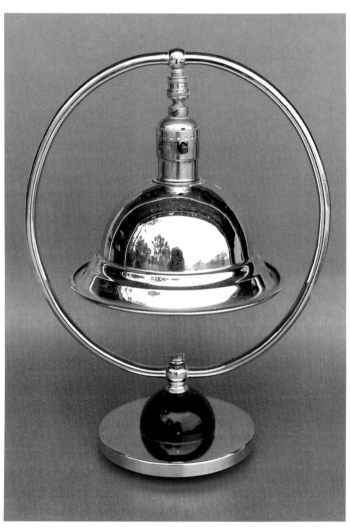

Polished chrome circle lamp, 12" high and 9½" wide at its greatest width.

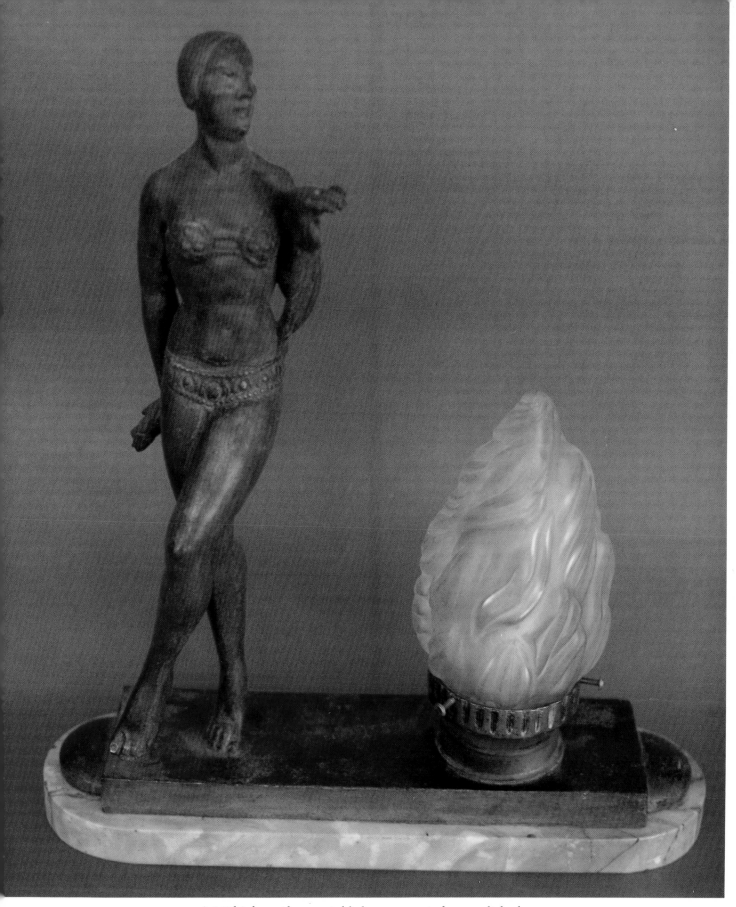

A 14" high cast bronze table lamp mounted on a polished marble base. The metal portion is signed by the artist, M. Salvado.

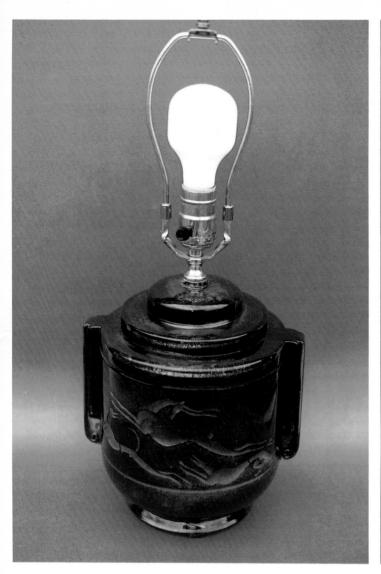
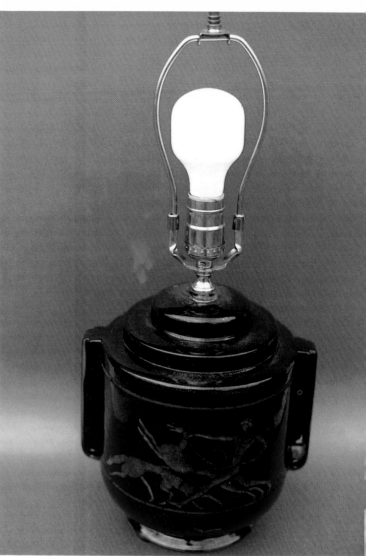

Two views of a molded glass lamp base with geometric styling and a conventionalized wraparound hunting scene. Overall height is 18″.

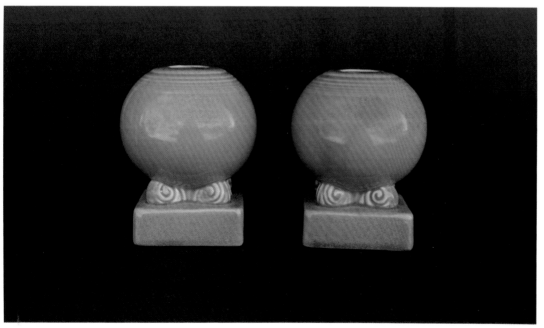

A pair of bulb-type Fiesta Ware candle holders, 3¾″ high.

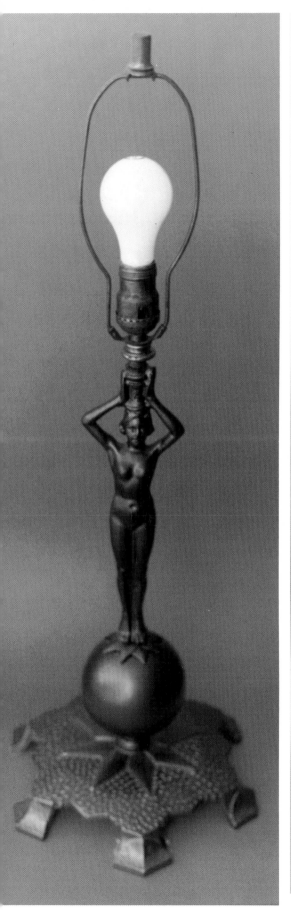

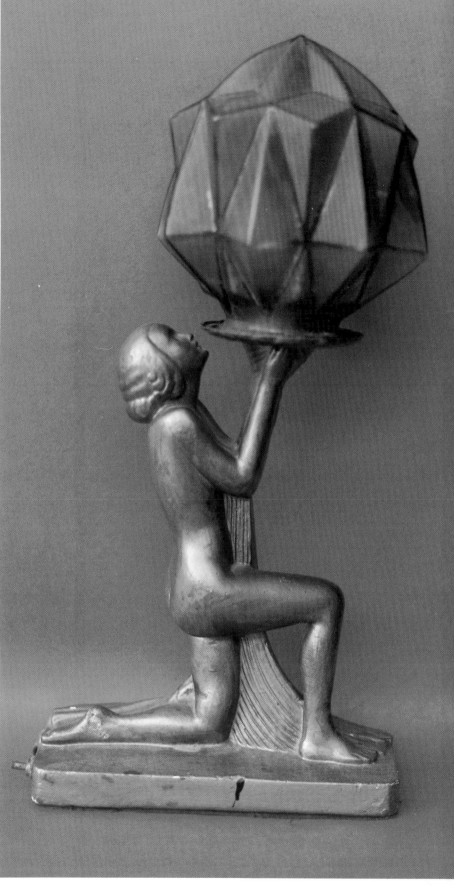

A 29½" high cast iron standing nude figural table lamp.

An 18" high plaster figural lamp with a geometric green globe.

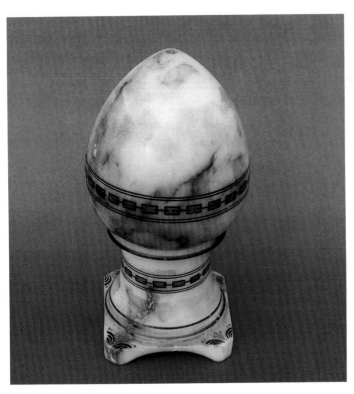

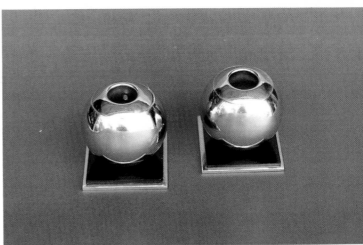

A pair of Chase polished chrome and blue mirror candlesticks. They measure 2½" high, base s 2½" square.

An 8½" high carved and enameled alabaster Art Deco boudoir lamp.

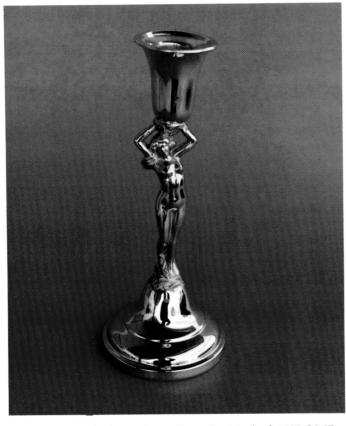

An 8½" high figural candlestick. Marked "KROME-KRAFT, Farber Brothers, New York, NY."

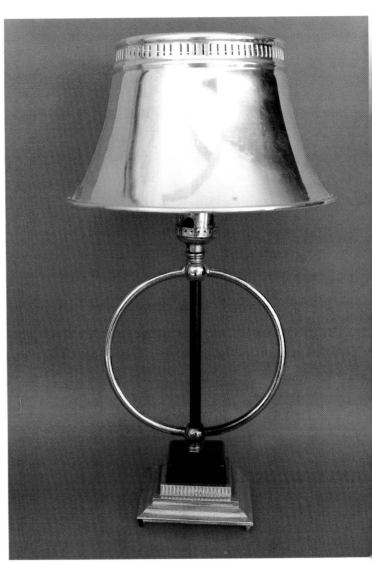

Chrome and black enamel circle lamp with matching pierced, flared shade, 16" high.

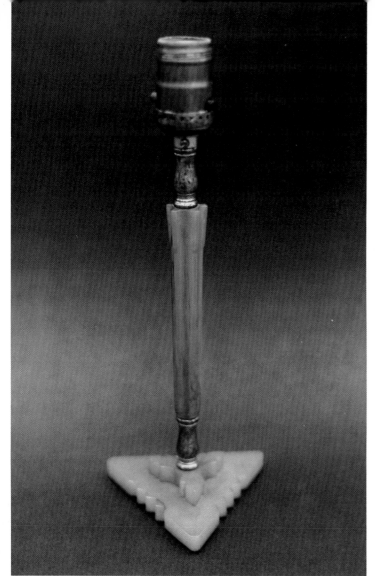

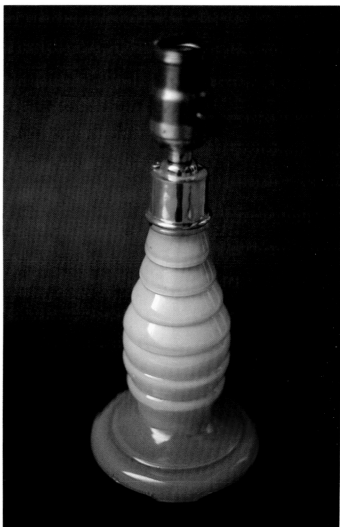

A 12" high Bakelite lamp with fluted body and carved triangular base.

An 11" high electric lamp with brightly colored stacked disc glass body.

Electric wall sconces made from spun, polished chrome, 4" high, 8" long.

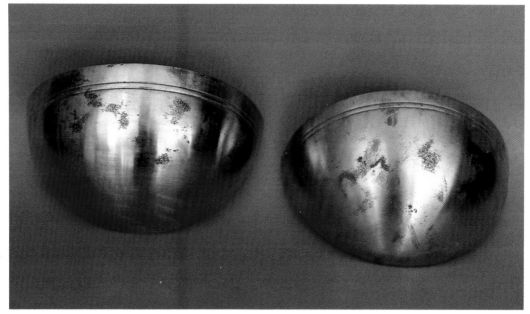

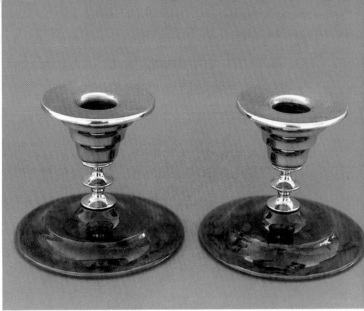

A pair of 4" high stacked-disc design chrome and Bakelite candlesticks.

An 11" long wall lighting sconce with spiderweb and fly theme. This very unusual piece is made from painted cast iron and frosted glass.

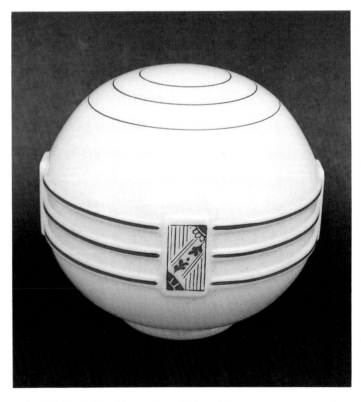

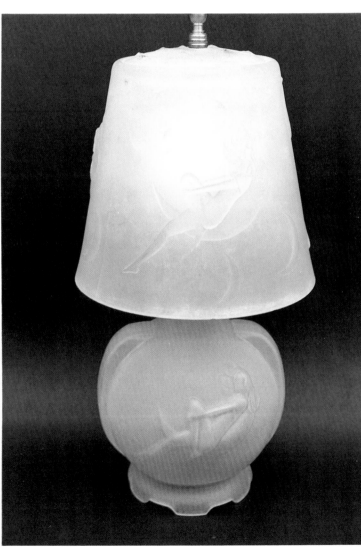

A 7¼" high Art Deco glass light globe.

A 14½" high frosted glass "Woman in the Moon" table lamp.

Price Guide

Front cover:	$70.00—$90.00
Title page:	$75.00—$95.00
Page 2:	$25.00—$35.00
Page 3 plate:	$7.00—$9.00
creamer:	$10.00—$12.00
vase:	$40—45.00
Page 4:	$180.00—$235.00
Page 5:	$150.00—$200.00.
Page 6:	$1200.00—$1500.00.
Page 7:	$165.00—$190.00.
Page 8:	$125.00—150.00/pair:
Page 9 top:	$50.00—$60.00/set.
bottom:	$30.00—$40.00/pair.
Page 10 left:	$75.00—$100.00.
right:	$110.00—$140.00.
Page 11 left:	$25.00—$35.00.
right:	$450.00—$550.00.
Page 12:	$175.00—$200.00.
Page 13 top left:	$125.00—$150.00.
bottom left:	$170.00—$200.00.
right:	$900.00—$1100.00.
Page 14 left:	$95.00—$110.00.
right:	$60.00—$75.00.
Page 15 left:	$80.00—$95.00.
right:	300.00—$350.00.
Page 16 left:	$175.00—$225.00/pair.
right:	$150.00—$170.00/each.
Page 17 left:	$40.00—$45.00.
right:	$55.00—$65.00.
Page 18:	$40.00—$50.00.
Page 19:	$4000.00—$5000.00.
Page 20:	$350.00—$450.00+.

ART GLASS

Page 22 left:	$110.00—$135.00.
right:	$375.00—$450.00.
Page 23 top:	$45.00—$55.00.
bottom left:	$85.00—$100.00.
bottom right:	$40.00—$50.00.
Page 24:	$250.00—$275.00.
Page 25 top left:	$225.00—$265.00.
bottom left:	$350.00—$400.00.
right:	$60.00—$80.00.
Page 26:	$1500.00—$1750.00.
Page 27:	$850.00—$1000.00.
Page 28 top:	$95.00—$115.00.
bottom:	$65.00—$80.00.
Page 29 top left:	$300.00—$375.00.
bottom left:	$750.00—$850.00.

ART METAL

Page 29 right:	$165.00—$200.00.
Page 30 left:	$100.00—$125.00.
top right:	$50.00—$65.00.
bottom right:	$175.00—$225.00.
Page 31 top left:	$75.00—$90.00.
bottom left:	$300.00—$425.00.
right:	$125.00—$150.00.
Page 32 top left:	$125.00—$145.00.
bottom left:	$120.00—$140.00.
top right:	$30.00—$35.00.
bottom right:	$60.00—$80.00.
Page 33 top left:	$60.00—$80.00.
top right:	$90.00—$135.00.
bottom left:	$150.00—$175.00.
bottom right:	$110.00—$135.00.
Page 34 top left:	$60.00—$75.00.
top right:	$1500.00—$1800.00.

ART POTTERY

Page 34 bottom:	$120.00—$140.00/set.
Page 35 top left:	$125.00—$150.00.
top right:	$65.00—$80.00.
bottom:	$40.00—$50.00.
Page 36 top:	$25.00—$35.00.
bottom left:	$75.00—$110.00.
bottom right:	$70.00—$85.00.
Page 37 top left:	$210.00—$250.00.
bottom left:	$95.00—$125.00.
top right:	$2300.00—$2500.00.
bottom right:	$75.00—$95.00.
Page 38 left:	$100.00—$125.00.
top right:	$120.00—$140.00.
bottom right:	$55.00—$70.00.
Page 39 top:	$425.00—$475.00.
bottom left:	$70.00—$95.00.
bottom right:	$160.00—$185.00.
Page 40:	$400.00—$450.00.
Page 41 top left:	$35.00—$45.00.
top right:	$125.00—$170.00.

BAR ACCESSORIES

Page 41 bottom:	$150.00—$175.00.
Page 42 top left:	$40.00—$50.00.
bottom left:	$100.00—$120.00.
top right:	$25.00—$35.00.
bottom right:	$15.00—$20.00.
Page 43 top left:	$20.00—$30.00.
bottom left:	$18.00—$25.00.
top right:	$65.00—$85.00.
bottom right:	$35.00—$40.00.
Page 44 top left:	$50.00—$65.00.
bottom left:	$50.00—$60.00.
top right:	$10.00—$12.00.
bottom right:	$20.00—$25.00.
Page 45 top left:	$160.00—$180.00.
bottom left:	$125.00—$150.00.
top right:	$30.00—$35.00/set.
center right:	$450.00—$500.00/set.
bottom right:	$30.00—$40.00.
Page 46 top left:	$95.00—$125.00.
bottom left:	$40.00—$50.00.
top right:	$30.00—$40.00.
bottom right:	$100.00—$125.00.

BOOKENDS

Page 47 top left:	$35.00—$45.00.
bottom left:	$50.00—$65.00.
top right:	$110.00—$125.00/pair.
bottom right:	$50.00—$65.00/pair.
Page 48 top left:	$50.00—$65.00/pair.
center:	$125.00—$150.00/pair.
bottom right:	$120.00—$140.00/pair.
Page 49 top left:	$150.00—$200.00/pair.
center:	$20.00—$30.00/pair.
bottom right:	$85.00—$100.00.
Page 50 top left:	$85.00—$100.00.
bottom left:	$85.00—$100.00/pair.
top right:	$50.00—$65.00.
bottom right:	$70.00—$85.00.
Page 51 top left:	$65.00—$80.00.
bottom left:	$50.00—$65.00.
top right:	$30.00—$40.00/pair.
bottom right:	125.00—$145.00.
Page 52 top left:	$150.00—$175.00/pair.
Center	$95.00—$135.00/pair.
bottom right:	$90.00—$110.00/pair.

CLOCKS

Page 53 top left:	$200.00—$250.00.
bottom:	$550.00—$700.00.
Page 54 top:	$250.00—$300.00.
bottom left:	$40.00—$55.00.
bottom right:	$125.00—$150.00.
Page 55 top:	$175.00—$250.00.
bottom left:	$90.00—$120.00.
bottom right:	$50.00—$65.00.
Page 56 top:	$275.00—$325.00.
bottom:	$300.00—$350.00.
Page 57 top:	$150.00—$175.00.
bottom left:	$150.00—$190.00.
bottom right:	$65.00—$85.00.
Page 58 top:	$40.00—$65.00.
bottom:	$25.00—$35.00.
Page 59 top:	$1200.00—$1500.00.
bottom left:	$100.00—$125.00.
bottom right:	$70.00—$90.00.
Page 60 top left:	$65.00—$80.00.
bottom left:	$125.00—$150.00.
top right:	$95.00—$125.00.
bottom right:	$65.00—$80.00.
Page 61:	$100.00—$135.00.
Page 62 top:	$2200.00—$2500.00.
bottom:	$150.00—$175.00.
bottom right:	$75.00—$95.00.

DESK ITEMS

Page 63 top:	$250.00—$290.00.
bottom right:	$65.00—$80.00.
Page 64 top:	$120.00—$150.00.
bottom left:	$175.00—$225.00.
bottom right:	$75.00—$85.00/set.
Page 65 top:	$50.00—$65.00.
bottom left:	$95.00—$120.00.
bottom right:	$85.00—$125.00.
Page 66 top:	$85.00—$120.00.
bottom left:	$10.00—$15.00.
bottom right:	$6.00—$10.00.
Page 67 top right:	$60.00—$75.00 each.
bottom:	$75.00—$95.00.
Page 68 top left:	$90.00—$120.00.
center left:	$40.00—$55.00.
bottom left:	$75.00—$90.00 each.
top right:	$55.00—$70.00.
center right:	$15.00—$20.00.
Bottom right:	$20.00—$30.00 each.

DRESSER ITEMS

Page 69 top left:	$75.00—$100.00.
bottom:	$125.00—$150.00.
top right:	$45.00—$60.00.
Page 70 left:	$50.00—$65.00.
right:	$25.00—$30.00.
Page 71 top left:	$70.00—$85.00.
bottom:	$30.00—$40.00.
top right:	$75.00—$90.00.
Page 72 top left:	$75.00—$90.00.
bottom:	$125.00—$150.00.
top right:	$60.00—$80.00.
Page 73 top:	$175.00—$225.00.
bottom:	$40.00—$45.00.
Page 74 top left:	$35.00—$40.00.
bottom:	$25.00—$30.00.
top right-7½":	$75.00—$90.00.
2½":	$30.00—$40.00.
Page 75 top left:	$15.00—$20.00.

bottom left:	$45.00—$60.00/set.
top right:	$25.00—$35.00.
center right:	$30.00—$40.00/set.
bottom right:	$60.00—$80.00.
Page 76 top left:	$20.00—$25.00.
center right:	$65.00—$90.00 each.

FIGURINES

Page 76 bottom:	$175.00—$225.00.
Page 77:	$1900.00—$2100.00.
Page 78 left:	$375.00—$425.00.
top right:	$35.00—$45.00.
bottom right:	$110.00—$140.00.
Page 79 top:	$375.00—$425.00.
bottom left:	$110.00—$135.00.
bottom right:	$175.00—$225.00.
Page 80 left:	$500.00—$600.00.
top right:	$70.00—$90.00.
bottom right:	$110.00—$130.00.
Page 81 top:	$225.00—$300.00.
bottom:	$140.00—$180.00.
Page 82:	$1000.00—$1200.00.
Page 83:	$600.00—$700.00.
Page 84 left:	$120.00—$150.00.
top right:	$175.00—$200.00.
bottom right:	$90.00—$115.00.

JEWELRY

Page 85 top left:	$75.00—$95.00.
bottom:	$40.00—$45.00.
top right:	$20.00—$30.00 each.
Page 86 top left-	
earrings:	$20.00—$30.00.
ring box:	$20.00—$25.00.
center left:	$18.00—$25.00.
bottom left:	$10.00—$15.00.
top right:	$25.00—$35.00.
center right:	$12.00—$18.00/pair.
bottom right:	$35.00—$45.00 each.
Page 87 top:	$50.00—$60.00/set.
bottom-	
bracelets:	$25.00—$30.00 each.
necklaces:	$35.00—$50.00 each.
pin:	$20.00—$25.00.
Page 88 left:	$125.00—$150.00.
top right:	$20.00—$25.00 each.
center right:	$50.00—$65.00.
bottom right:	$20.00—$25.00 each.
Page 89 top:	$30.00—$45.00 each.
bottom:	$110.00—$150.00 each.
Page 90 top left:	$350.00—$450.00+.
bottom right:	$250.00—$350.00+.
Page 91 left:	$175.00—$225.00+.
top right:	$300.00—$375.00+each.
bottom right:	$175.00—$250.00+each.
Page 92 top left:	$80.00—$100.00.
bottom left	
-pin:	$35.00—$45.00.
bracelet:	$20.00—$30.00.
top right:	$65.00—$90.00.
bottom right:	$95.00—$120.00.

KITCHEN AND TABLEWARE

Page 93 top left:	$20.00—$25.00.
bottom:	$60.00—$75.00.
top right:	$20.00—$30.00/pair.
Page 94 top:	$90.00—$110.00/set.
bottom:	$50.00—$65.00/set.
Page 95 top:	$250.00—$300.00.
bottom left:	$7.00—$10.00 each.
bottom right:	$15.00—$20.00.
Page 96 top:	$95.00—$115.00.
bottom:	$30.00—$40.00.
Page 97 top left:	$45.00—$55.00.

bottom left:	$35.00—$45.00.
top right:	$30.00—$40.00.
bottom right:	$15.00—$20.00.
Page 98 top left:	$15.00—$20.00.
top right:	$30.00—$40.00.
bottom right:	$20.00—$25.00.
Page 99 top:	$60.00—$80.00.
bottom left:	$25.00—$35.00/set.
bottom right:	$20.00—$25.00/set.
Page 100 top left:	$50.00—$65.00.
bottom left:	$20.00—$30.00.
top right:	$65.00—$85.00.
bottom right:	$15.00—$20.00.
Page 101 top left:	$45.00—$65.00.
bottom:	$90.00—$120.00.
top right:	$35.00—$45.00.
Page 102 top left:	$20.00—$25.00.
bottom:	$30.00—$40.00/set.
top right:	$20.00—$25.00.
Page 103 top left:	$45.00—$60.00.
bottom:	$25.00—$30.00 each.
top right:	$110.00—$135.00/set.
Page 104 top left:	$20.00—$25.00.
bottom right:	$20.00—$25.00.
top right:	$20.00—$30.00.
bottom right:	$30.00—$40.00.

LAMPS AND LIGHTING

Page 105 left:	$325.00—$375.00.
right:	$300.00—$350.00.
Page 106 top left:	$120.00—$140.00/pair.
bottom left:	$50.00—$65.00.
top right:	$20.00—$25.00.
bottom right:	$75.00—$90.00.
Page 107:	$500.00—$600.00+.
Page 108 top:	$100.00—$135.00.
bottom left:	$30.00—$35.00.
Page 109 left:	$200.00—$225.00.
right:	$150.00—$180.00.
Page 110 top left:	$125.00—$150.00.
bottom left:	$25.00—$30.00.
top right:	$45.00—$55.00/pair.
Bottom right:	$40.00—$50.00.
Page 111 top left:	$55.00—$65.00.
top right:	$30.00—$45.00.
bottom right:	$60.00—$75.00/pair
Page 112 top left:	$200.00—$235.00.
bottom left:	$25.00—$35.00.
top right:	$45.00—$60.00/pair.
bottom right:	$175.00—$225.00.
Page 113:	$250.00—$300.00.
Page 114:	$800.00—$1200.00.
Page 115 top:	$900.00—$1200.00.
bottom:	$450.00—$500.00.
Page 116 top:	$500.00—$600.00.
bottom:	$12.00—$18.00.

MISCELLANEOUS AND ODDITIES

Page 117 left:	$95.00—$115.00.
top right:	$25.00—$30.00 each.
bottom right:	$15.00—$20.00.
Page 118 left:	$75.00—$100.00.
top right:	$90.00—$110.00.
center right:	$35.00—$40.00.
bottom right:	$110.00—$130.00.
Page 119 top:	$70.00—$85.00.
bottom left:	$70.00—$100.00.
center right:	$40.00—$50.00.
bottom right:	$60.00—$75.00.
Page 120:	$125.00—$150.00.
Page 121 top left:	$135.00—$170.00.
top right:	$10.00—$15.00.
bottom right:	$12.00—$18.00.

Page 122 top left:	$25.00—$35.00.
bottom left:	$15.00—$20.00 each.
top right:	$40.00—$50.00.
bottom right:	$70.00—$85.00.
Page 123 left:	$35.00—$45.00.
top right:	$35.00—$45.00.
bottom right:	$20.00—$25.00.
Page 124:	$25.00—$35.00.
Page 125 top:	$100.00—$125.00.
bottom left:	$35.00—$45.00.
bottom right:	$60.00—$75.00.

PURSES

Page 126 top left:	$70.00—$80.00.
bottom left:	$25.00—$35.00.
top right:	$60.00—$75.00.
bottom right:	$30.00—$40.00.
Page 127 left:	$70.00—$85.00.
right:	$40.00—$50.00.
Page 128 top left:	$100.00—$125.00.
bottom left:	$60.00—$70.00.
top right:	$50.00—$60.00.
bottom right:	$50.00—$60.00.
Page 129 top left:	$75.00—$95.00.
bottom left:	$75.00—$90.00.
top right:	$95.00—$110.00.
bottom right:	$55.00—$70.00.
Page 130 top left:	$40.00—$50.00.
bottom left:	$35.00—$45.00.
top right:	$30.00—$40.00.
bottom right:	$45.00—$60.00.

SMOKING ACCESSORIES

Page 131 top	
right:	$25.00—$30.00.
bottom:	$150.00—$175.00.
Page 132 top:	$160.00—$185.00.
bottom left:	$50.00—$70.00.
center right:	$45.00—$60.00.
bottom right:	$20.00—$25.00 each.
Page 133 top:	$200.00—$250.00.
bottom:	$145.00—$165.00.
Page 134 left:	$170.00—$200.00.
right:	$140.00—$175.00.
Page 135 top left:	$75.00—$90.00.
bottom left:	$20.00—$25.00 each.
top right:	$25.00—$35.00.
bottom right:	$25.00—$30.00.
Page 136 top:	$70.00—$85.00.
bottom left:	$135.00—$150.00.
center right:	$20.00—$25.00.
bottom right:	$40.00—$50.00 each.
Page 137 top:	$130.00—$165.00.
center left:	$25.00—$35.00.
bottom left:	$65.00—$80.00.
bottom right:	$15.00—$20.00.
Page 138 top left:	$35.00—$45.00.
center left:	$40.00—$60.00.
bottom left:	$65.00—$80.00/set.
top right:	$70.00—$90.00.
Page 139 top:	$35.00—$45.00 each.
bottom left:	$60.00—$80.00.
bottom right:	$70.00—$90.00.
Page 140:	$500.00—$600.00+.
Page 141 top:	$90.00—$120.00.
bottom:	$30.00—$40.00.
Page 142 top:	$175.00—$250.00.
bottom left:	$100.00—$125.00.
Page 143 top:	$125.00—$150.00.
bottom right:	$25.00—$35.00.
Page 144:	$150.00—$200.00.

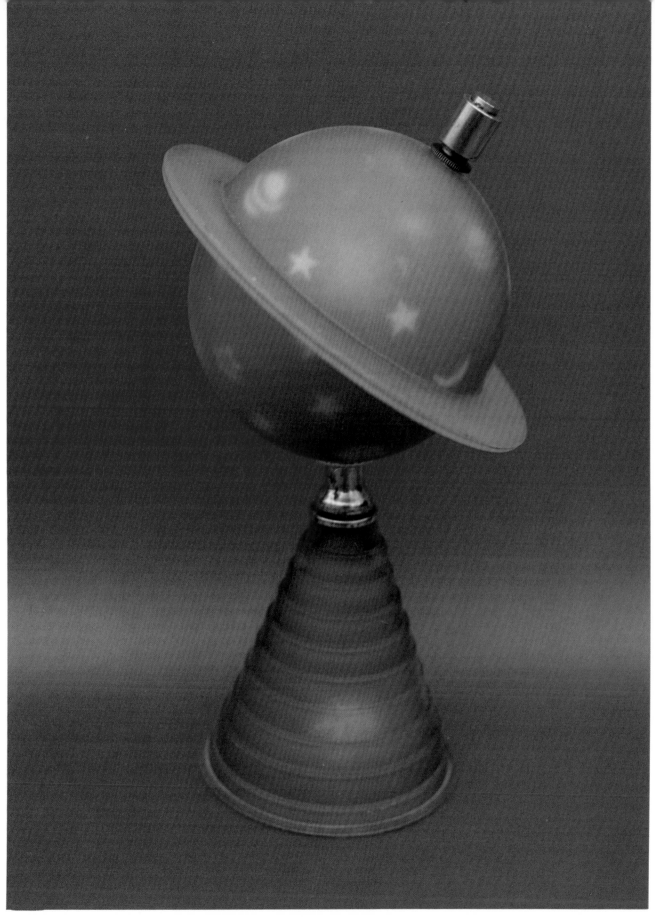

A very desirable Art Deco item is this 12½" high satin
glass table lamp in the form of Saturn.

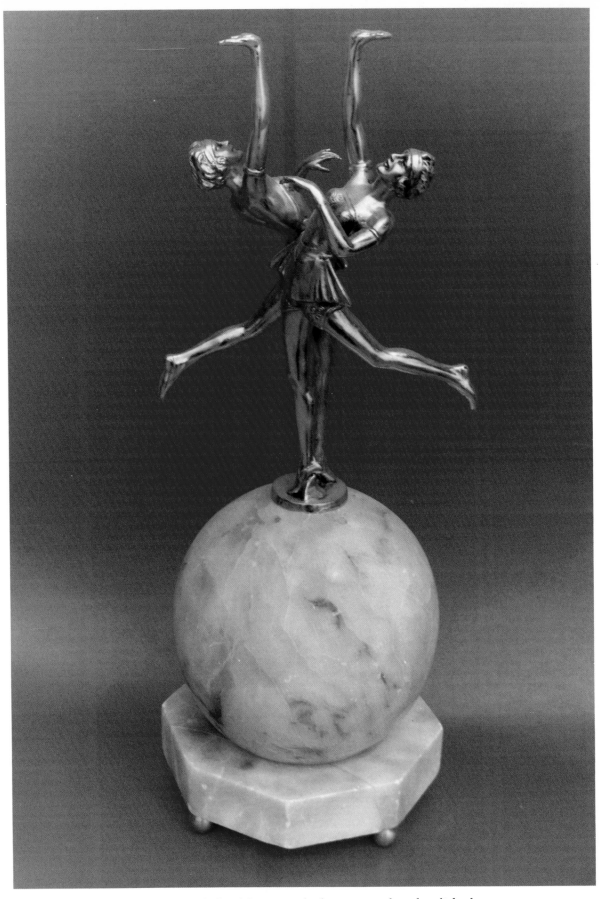

Interior-lighted lamp made from carved and polished
alabaster surmounted by gilt spelter figures, 16" high.

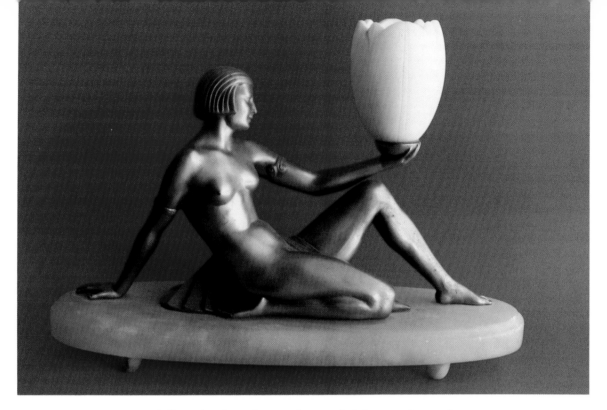

A French gilt spelter and carved alabaster electric lamp
exhibiting strong Egyptian influence, 11″ high, 15″ long.

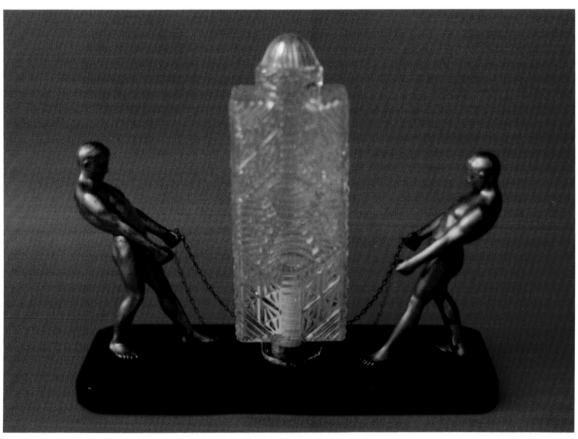

This cast metal Art Deco figural lamp is highly unusual
in that it features male subject matter. It measures 10″
high, 12″ long.

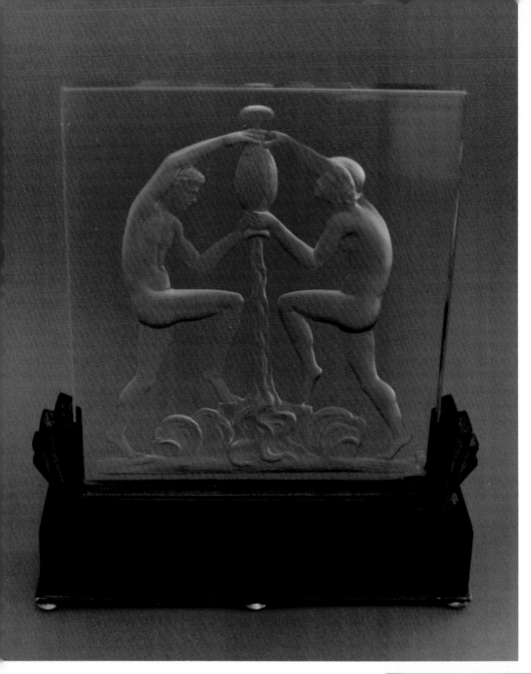

A spectacular luminaire made from a thick panel of intaglio-cut glass crystal featuring graceful classical figures. The panel is mounted in a metal base that lights from the bottom, thus illuminating the scene. It stands 13½" high and 11½" wide.

Pressed glass Art Deco candlestick, 5¼" high.

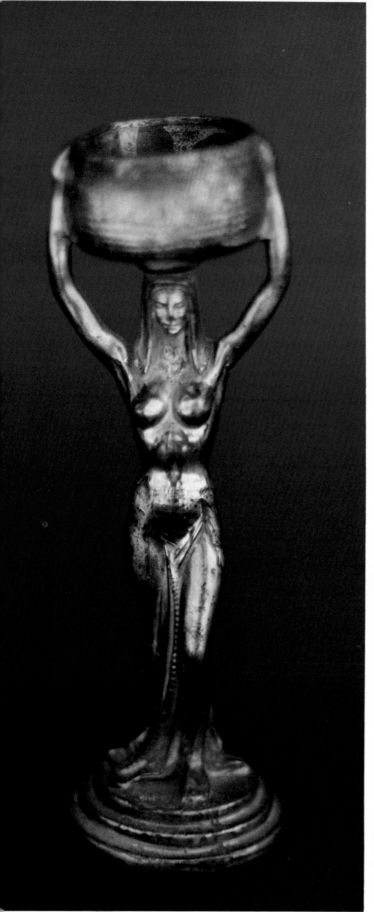

These 3¾" high Trylon and Perisphere thermometers are made of Bakelite and are souvenirs of the 1939 New York World's Fair.

Gilded bronze figural incense burner, 7¼" high.

Candy tin featuring a stylized skiing scene, 2" high, 9" long, 6" wide. Marked "J. Lyons & Co., London."

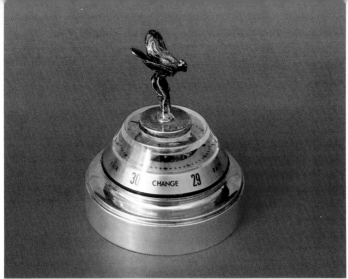

A 3½" high Tiffany & Co. barometer with a sterling base and figural finial.

Bakelite and chrome barometer marked "Taylor Baroguide," 4" high, 4¾" long.

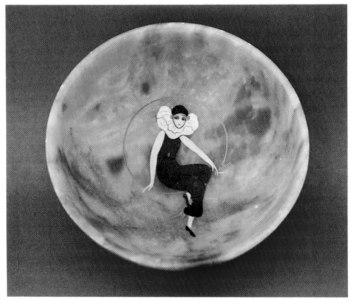

Although it dates from around the turn of the century, this 10" high Carter's cathedral ink bottle is popular with Art Deco collectors because of the strong geometric designs and cobalt blue color.

A finely carved soapstone bowl embellished with an enameled Art Deco figure, 3" high, 7" in diameter.

A 13½″ long cast metal figural incense burner displaying obvious Egyptian influence.

A 1933 Chicago World's Fair Century of Progress medal with a wonderful Art Deco design. Solid bronze, 2¾″ in diameter, designed by Emil Robert Zettler.

An 11″ high by 8″ wide Silvercrest bronze picture frame embellished with linework and stylized organics.

Semicircular plastic box with stepped design on the lid, 2″ high, 8½″ long, 3¾″ wide.

A 16″ high Art Deco globe with polished chrome airplane
base.

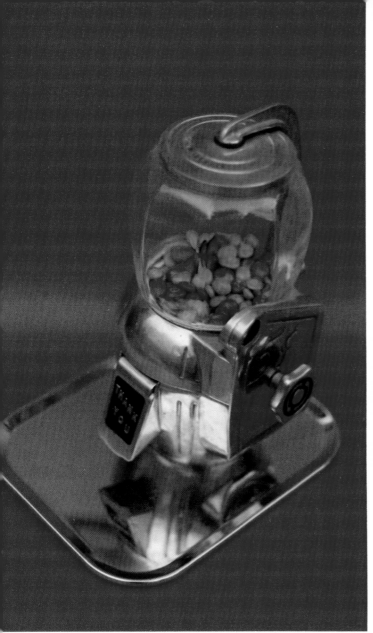

A 12″ high chrome and aluminum Art Deco style vending machine.

An Art Deco chromed steel electric iron with a plastic handle. Manufactured by Middleton & Mead Co., Inc., Baltimore, Maryland.

A deck of Art Deco playing cards.

An unusual black amethyst picture frame highlighted with geometric designs, 12" high and 10" wide.

A 9½" high milk glass souvenir bottle from the 1939 New York World's Fair.

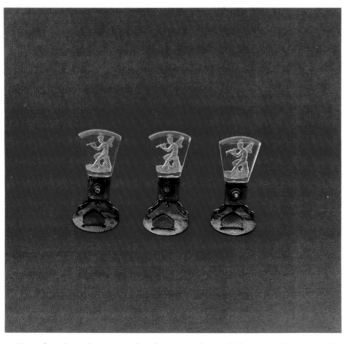

Czechoslovakian etched crystal and brass place-card holders

Chrome fireplace screen with stepped handle and geometric patterning.

An 11" long, 9" wide embossed and gilt leather photo album highlighted with Art Deco motifs.

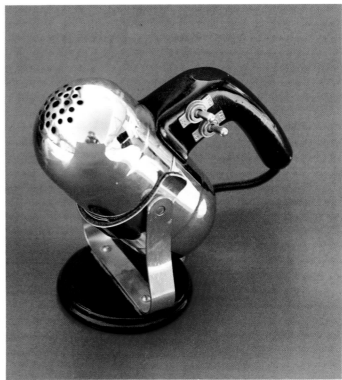

Art Deco fireplace set made from chromed metal. Overall height is 14".

A 7" high chrome and plastic hair dryer of decidedly futuristic design.

A 12″ high by 8″ wide chalkware plaque.

A 13¼″ long chromed steel hood ornament designed and signed by Petty.

A 10¾″ diameter souvenir plate commemorating the two-hundredth anniversary of the World's Fair as well as the 1939 New York World's Fair.

Multicolored Bakelite poker chips with matching caddy.

Purses

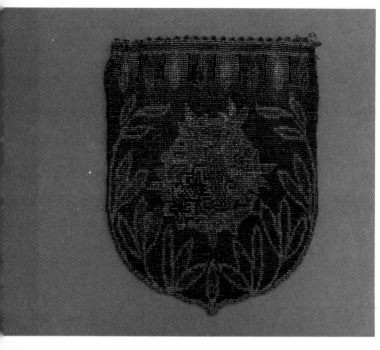

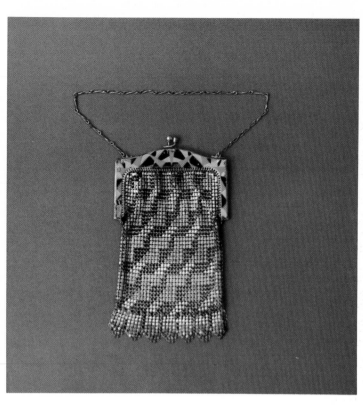

Drawstring bag made from colored metal beads, 6½" long, 5¼" wide. Stylized leaf and flower motifs.

Mesh bag with vivid enameled geometrics.

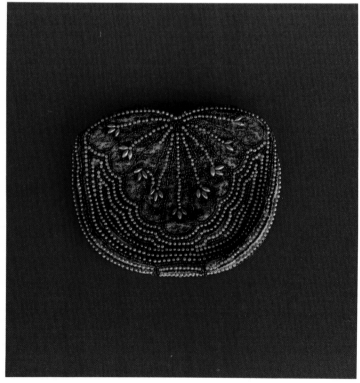

A black silk handbag with celluloid clasp and closure, 7½" wide.

Bead and faux pearl bag with pleasing linear design work, 5½" wide.

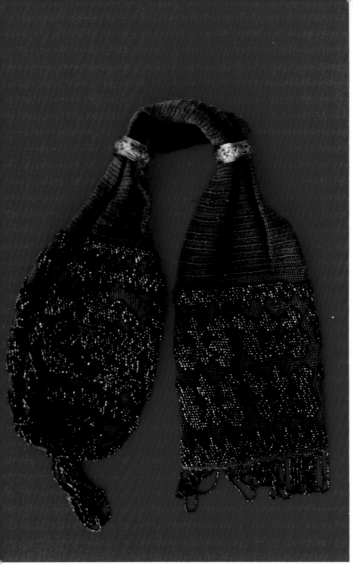

This 13″ long beaded purse was worn looped over a belt or sash. The purse ends contain slits through which items could be placed or removed.

A 6¾″ long beaded coin purse depicting a conventionalized butterfly.

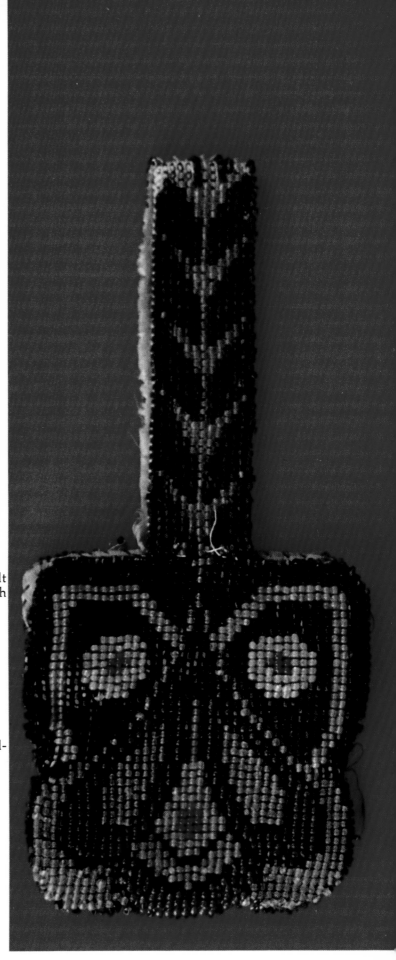

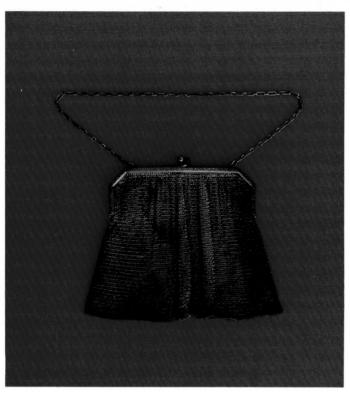

Sterling mesh purse, engraved and dated 1921.

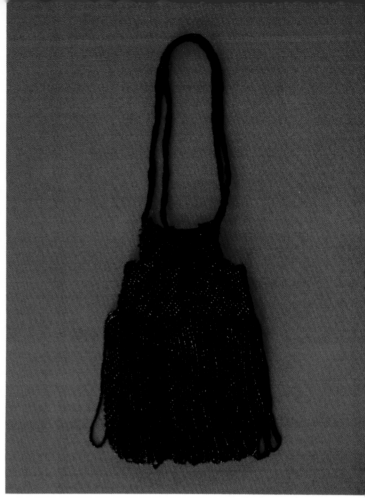

Black beaded handbag with fringe, 12" overall length.

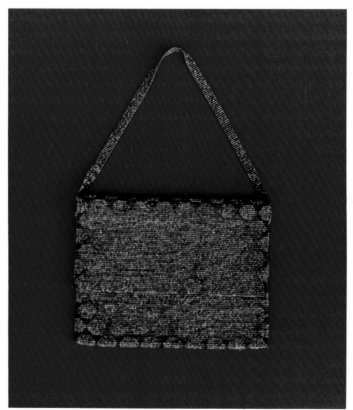

A 4" by 5½" handbag made from metallic beads. Note the geometric decor.

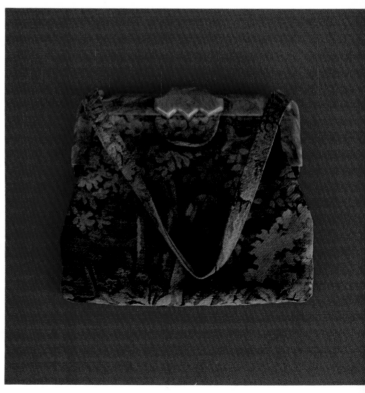

Tapestry purse with a Bakelite clasp and closure.

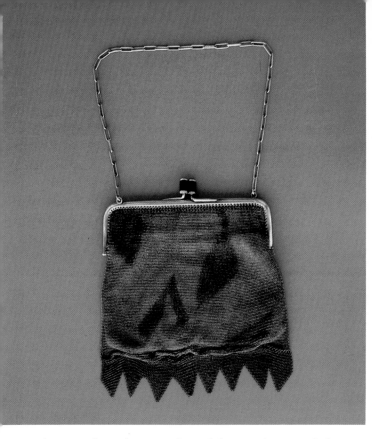

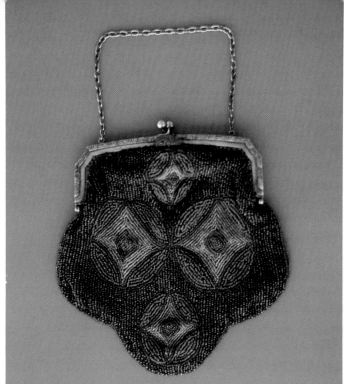

A finely beaded handbag embellished with geometrics. Overall length is 12".

An 11½" long fine metal mesh bag with enameled Deco designs and clasp.

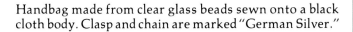

Handbag made from clear glass beads sewn onto a black cloth body. Clasp and chain are marked "German Silver."

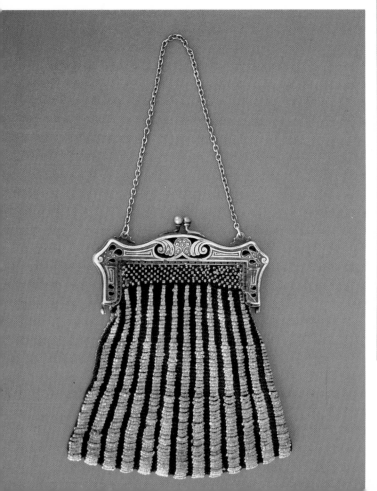

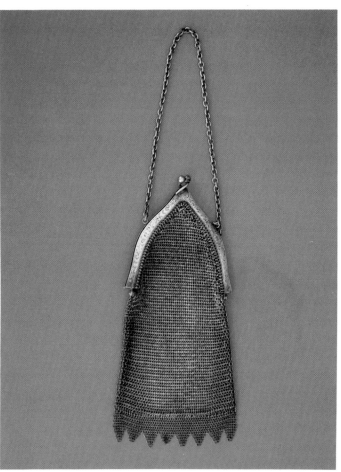

Whiting and Davis nickel-silver mesh evening bag. Overall length: 12", overall width, 3".

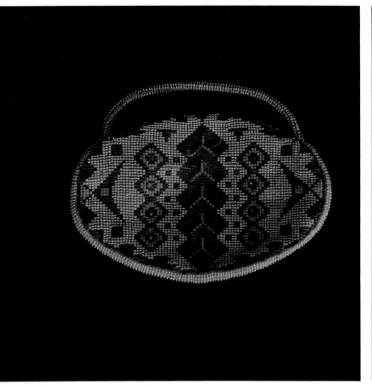

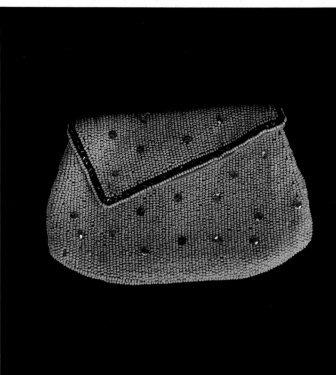

A 7" wide beaded handbag exhibiting strong geometric designs. Marked "Made in Czechoslovakia."

This attractive black and white handbag is made from beads, rhinestones, and sequins, and is 6½" wide.

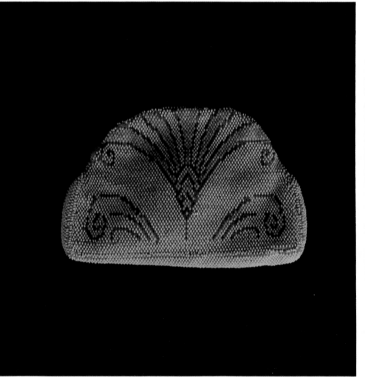

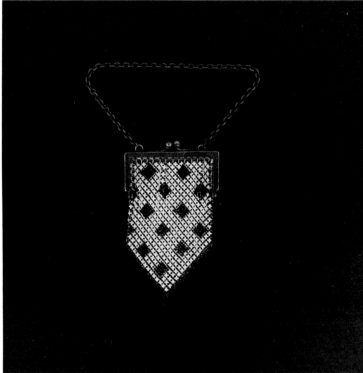

Czechoslovakian beaded bag with Art Deco patterning, 6" wide.

An enameled mesh coin purse highlighted with contrasting geometric forms.

3¼" high Bakelite container designed to hold a package of cigarettes.

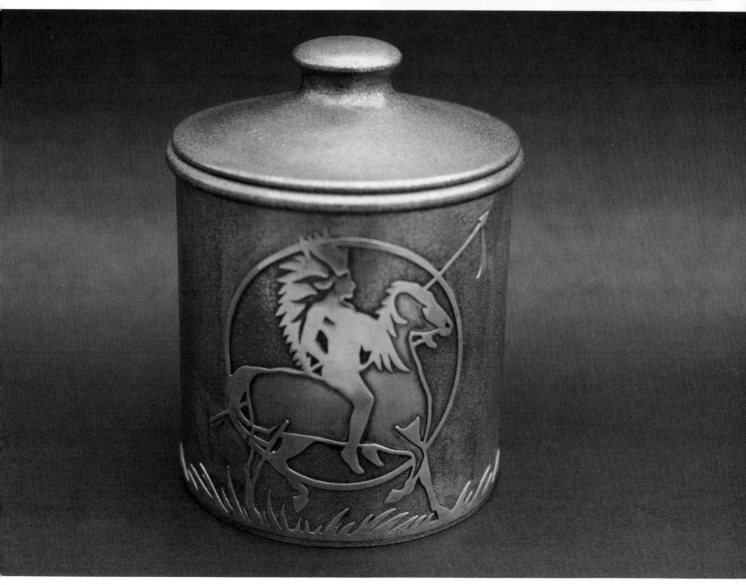

A 7" high Silvercrest bronze humidor with a highly stylized American Indian overlay.

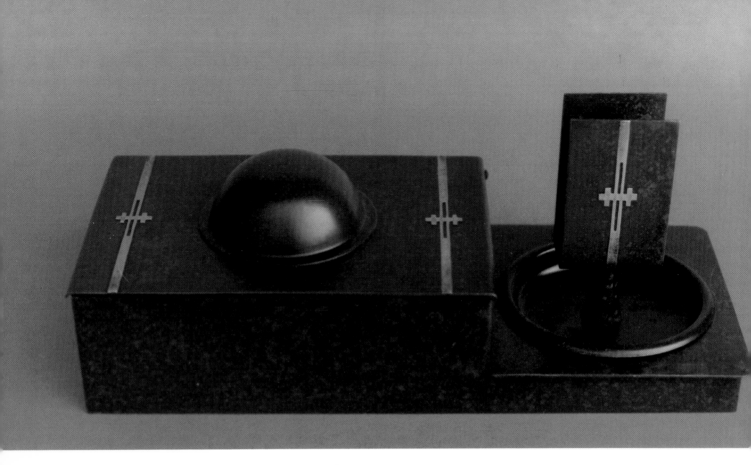

Heintz Art Metal sterling and bronze cigarette box with attached matchbox holder. Strong, futuristic design, 3" high, 10" long, 4" wide.

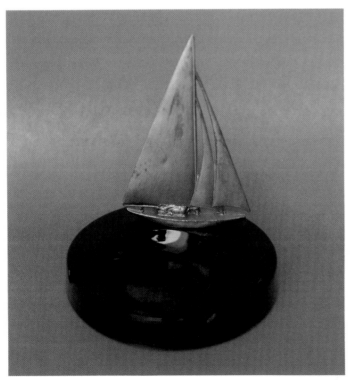

A cobalt glass ashtray with attached metal sailboat, 6½" high.

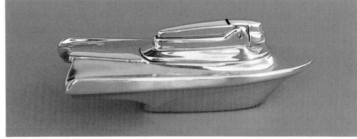

A Ronson polished chrome speedboat cigarette lighter, 2" high, 5½" long.

Bakelite cigarette and cigar holders, 2½" to 3¼" long.

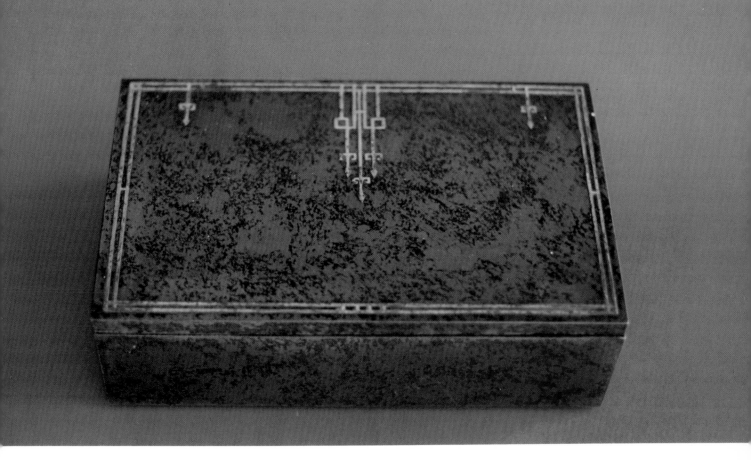

Heintz Art Metal bronze cigar box with beautiful green patina and an attractive geometric sterling silver overlay, 3" high, 10" long, 6" wide.

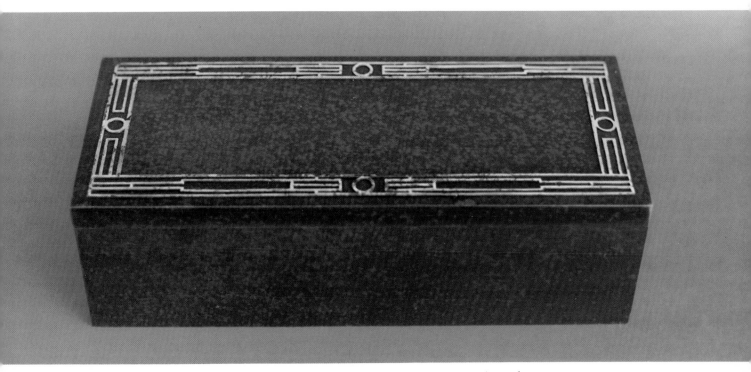

Bronze cigarette box with sterling linework and geometrics on the lid, 3" high, 8½" long, 3½" wide. Made by the Heintz Art Metal Shop.

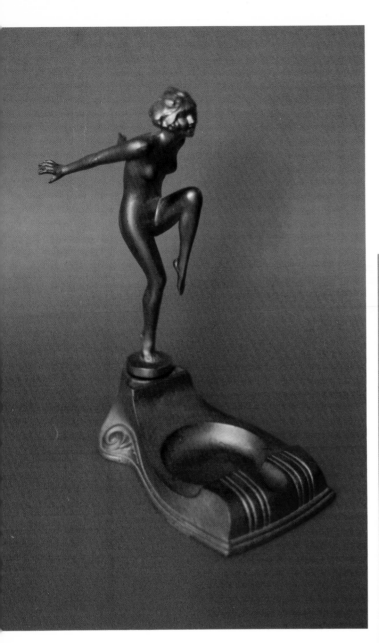

Cast metal figural ashtray with very strong overall design work, 9½" high.

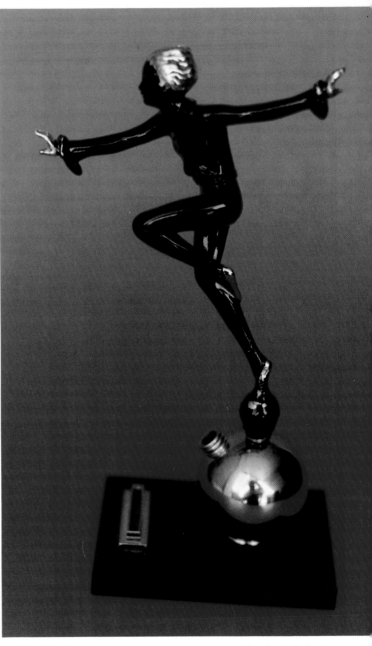

Enameled chrome figural lighter, 8¾" high. Made in England.

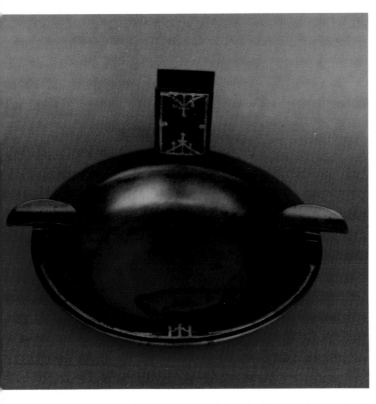

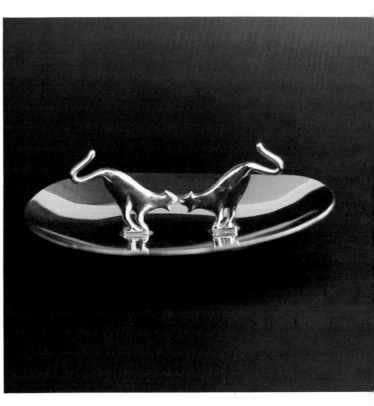

Heintz Art Metal ashtray/matchbox holder with attached cigarette rests and sterling Art Deco overlay, 4½" high, 9" in diameter.

Chrome ashtray with fighting cats cigarette rests, 2½" high, 7¼" long. Marked "Made in USA."

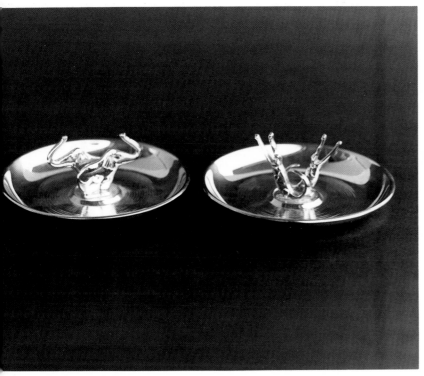

Chrome elephant and alligator ashtrays, 2" high, 4¼" diameter. Bases are marked "PINCHERETTE, Made in U.S.A."

A 5½" high chrome and Bakelite figural electric lighter.

Chase copper and Bakelite cigarette box, 1½" high, 8¾"
long, 3" wide.

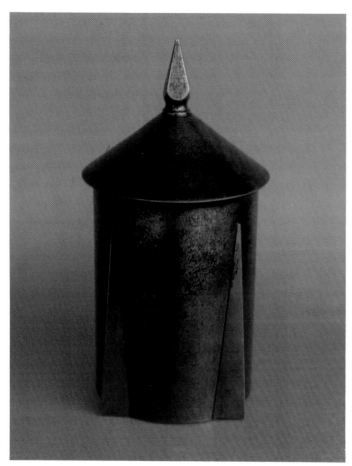

A 2½" high Chase cigarette cup.

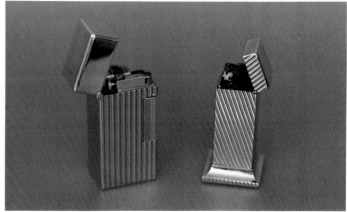

A very unusual 8½" high Silvercrest Art Deco humidor.

Chrome cigarette lighters made by Parker (left) and
Dunhill (right), 2½" and 3" high.

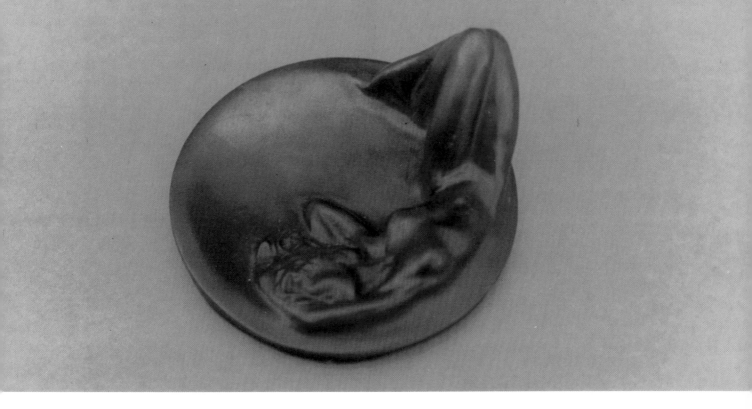

A 3″ high, 6″ diameter cast bronze ashtray with nude figurine.

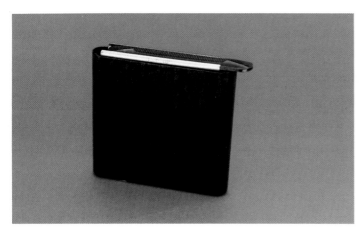

A 3½″ high Bakelite cigarette case/dispenser. This item is marked "Pop Up" and is spring-loaded to lift up cigarettes when the lid is slid open.

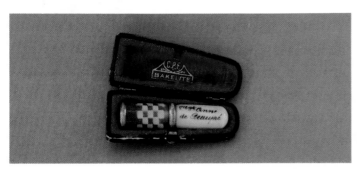

A carved Bakelite cigar holder complete with its original case.

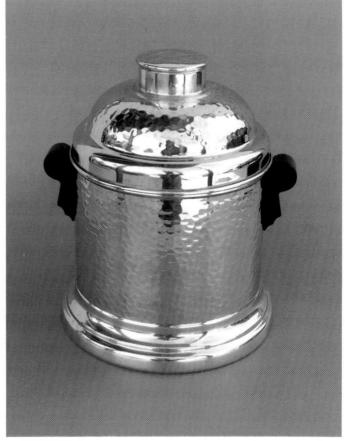

An 8″ high chromed brass humidor with stylized wood handles.

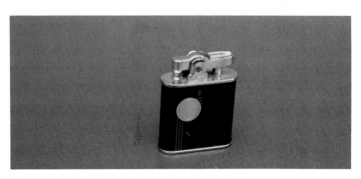

Pocket-style Ronson cigarette lighter with enameled geometric designs, 2¼" high.

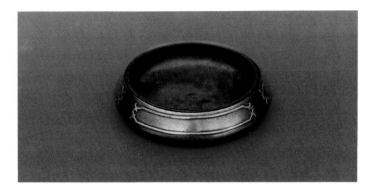

A 4" diameter bronze ashtray with sterling geometric overlay. Made by the Heintz Art Metal Shop.

Heintz smoking set consisting of a 2¼" high match holder and a 3¼" high cigarette cup. Solid bronze with a sterling Art Deco overlay.

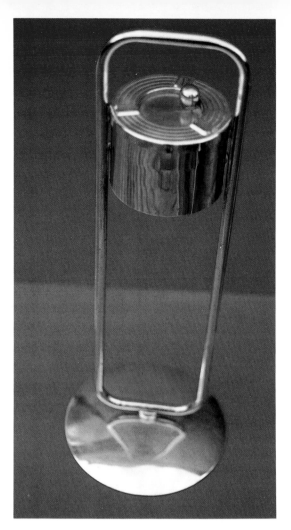

A 28" high chromed metal floor-standing ashtray with overall streamlined styling.

Colorful ceramic Art Deco lady head ashtrays, 4½" and 6½" long. Made in Japan.

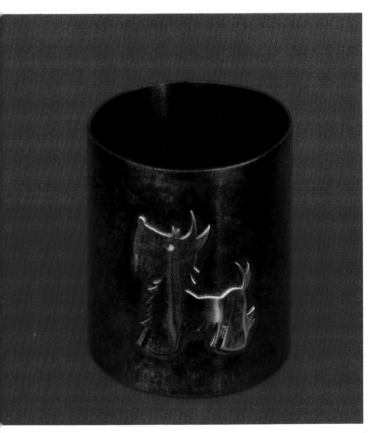

A 2" high Silvercrest bronze cigarette cup with scotty dog overlay.

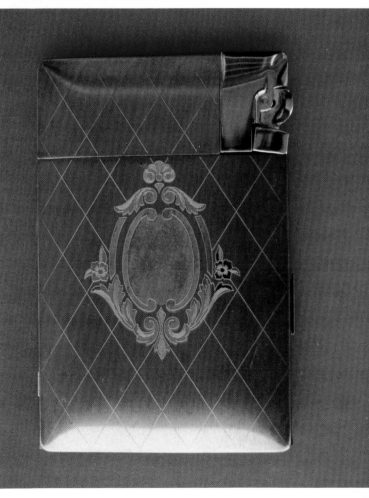

A 5" long by 3½" wide brass cigarette lighter/case with engraved Deco designs.

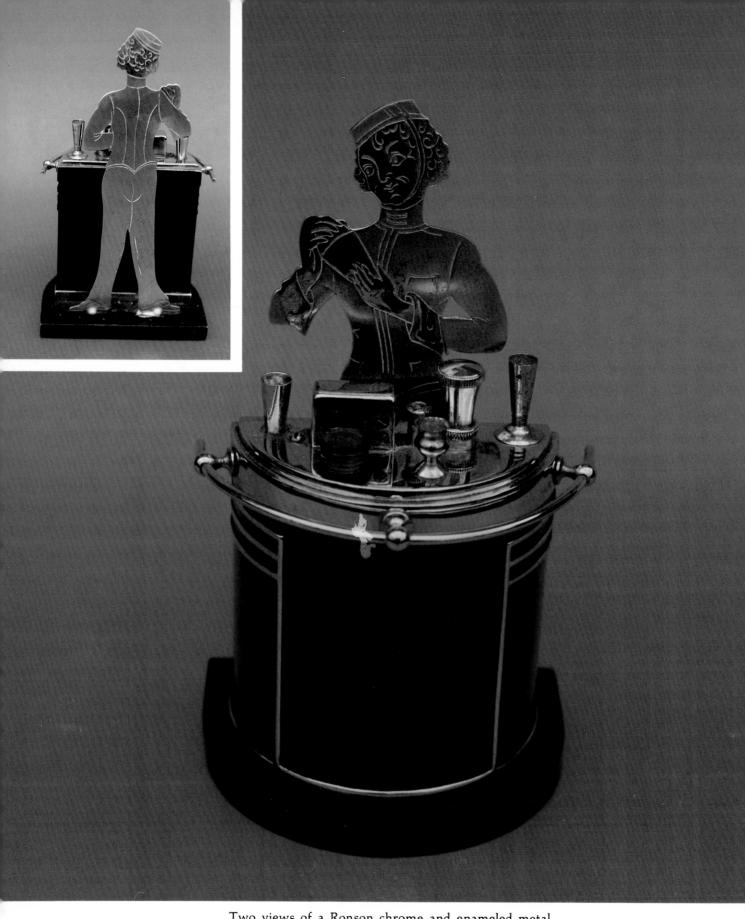

Two views of a Ronson chrome and enameled metal tabletop cigarette lighter in the form of a bartender. This is a much-sought-after item among Art Deco collectors.

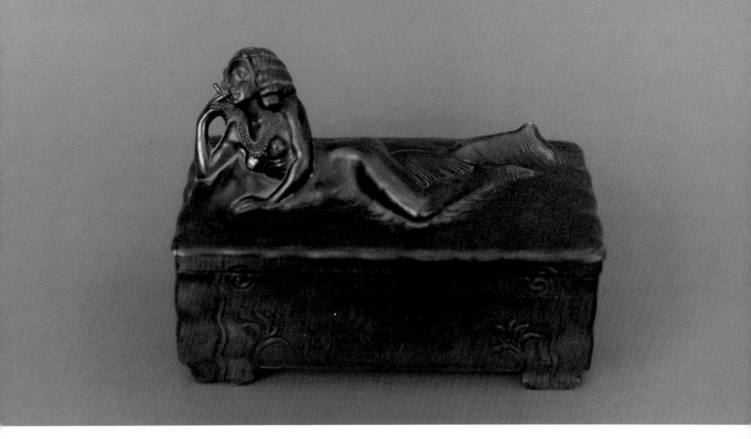

A superbly designed cigarette box with a reclining woman on the lid, 5" high, 6½" long, 3½" wide. Cast spelter with a bronze finish, made by Jennings Brothers.

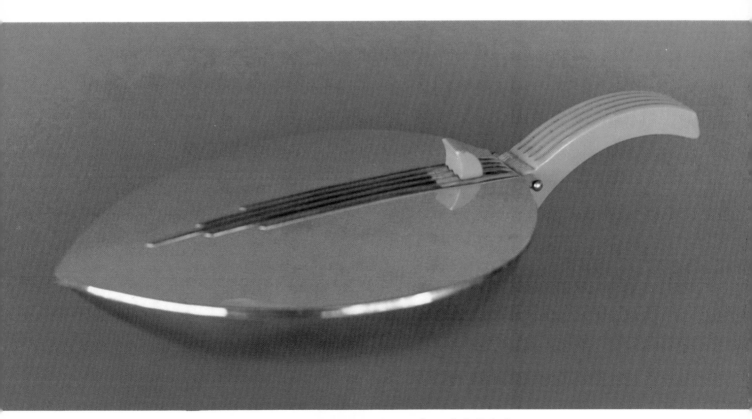

An 11" long Chase silent butler with stylish Bakelite fittings.

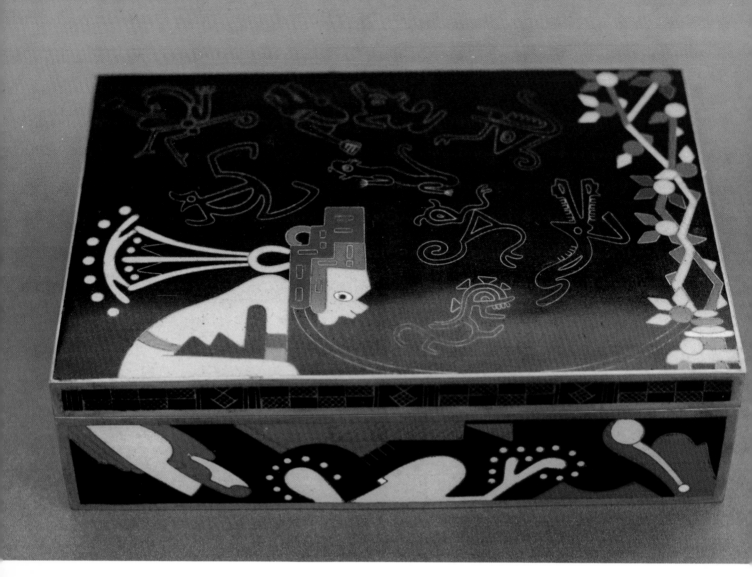

A cloisonne cigar box decorated with geometric designs of contrasting colors as well as modified Mayan themes, 2½" high, 9" long, 6¼" wide.

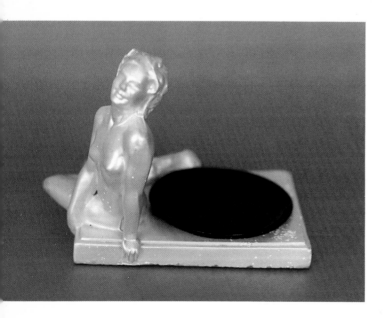

Frosted metal ashtray in the form of a reclining nude woman.

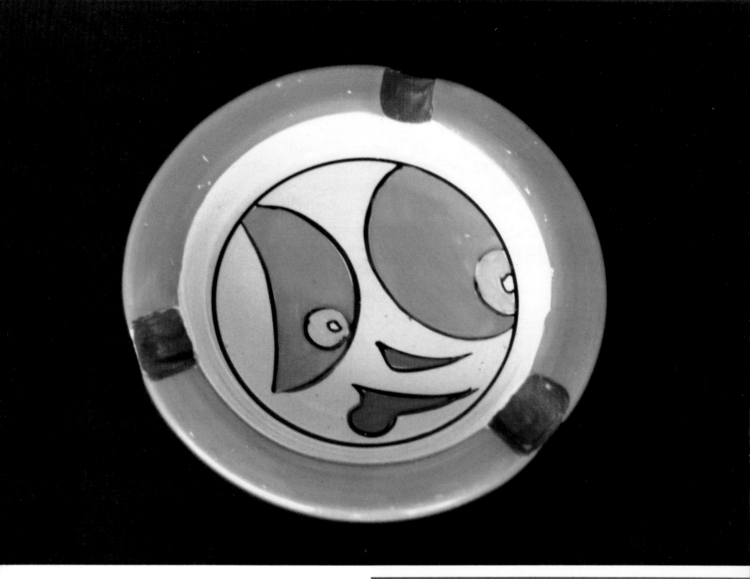

A 5″ diameter Clarice Cliff Bizarre Ware ashtray.

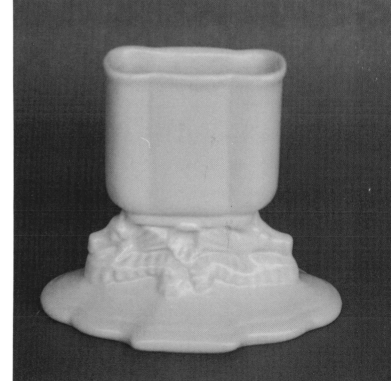

A 3¼″ high Cowan match holder with a seahorse base.

Bibliography

Arwas, Victor. *Art Deco*, New York: Harry N. Abrams, 1980.

Duke, Harvey. *Superior Quality Hall China*, Brooklyn, New York: ELO Books, 1984.

Fusco, Tony. *The Official Identification and Price Guide to Art Deco*, New York: House of Collectibles, 1988.

Gaston, Mary Frank. *Collector's Guide to Art Deco*, Paducah, Kentucky: Collector Books, 1987.

Griffin, Leonard, Louis Meisel, and Susan Meisel. *Clarice Cliff: The Bizarre Affair*, New York: Harry N. Abrams, 1988.

Haslam, Malcom. *Collector's Style Guide: Art Deco*, London: Macdonald and Company, Ltd., 1987.

Husfloen, Kyle, ed. *The Antique Trader Antiques and Collectibles Price Guide*, Dubuque, Iowa: Babka Publishing Company, 1989.

Huxford, Sharon and Bob. *Roseville Pottery*, Paducah, Kentucky: Collector Books, 1984.

Kelley, Lyngerda, and Nancy Schiffer. *Plastic Jewelry*, Exton, Pennsylvania: Schiffer Publishing Ltd., 1988.

Koch, Robert, ed. *Chase Chrome: The Chase Catalogue for 1936-37*, reprinted by Gladys Koch Antiques, Stamford, Connecticut, 1978.

McClinton, Katherine Morrison. *Art Deco: A Guide for Collectors*, New York: Clarkson N. Potter, 1986.

McConnell, Kevin. *Roycroft Art Metal*, Exton, Pennsylvania: Schiffer Publishing Ltd., 1990.

Sferrazza, Julie. *Farber Brothers Krome-Kraft*, Marietta, Ohio: Antique Publications, 1988.

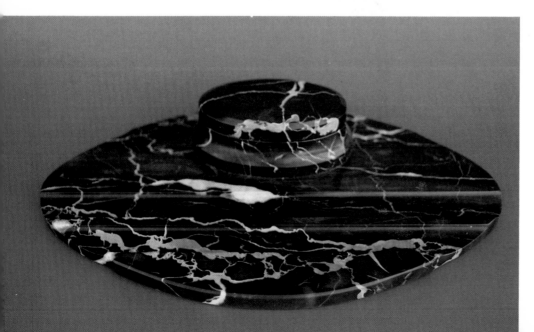

A polished marble desktop inkwell with hinged lid and pen grooves, 17½" long, 10" wide, and 3¾" high.

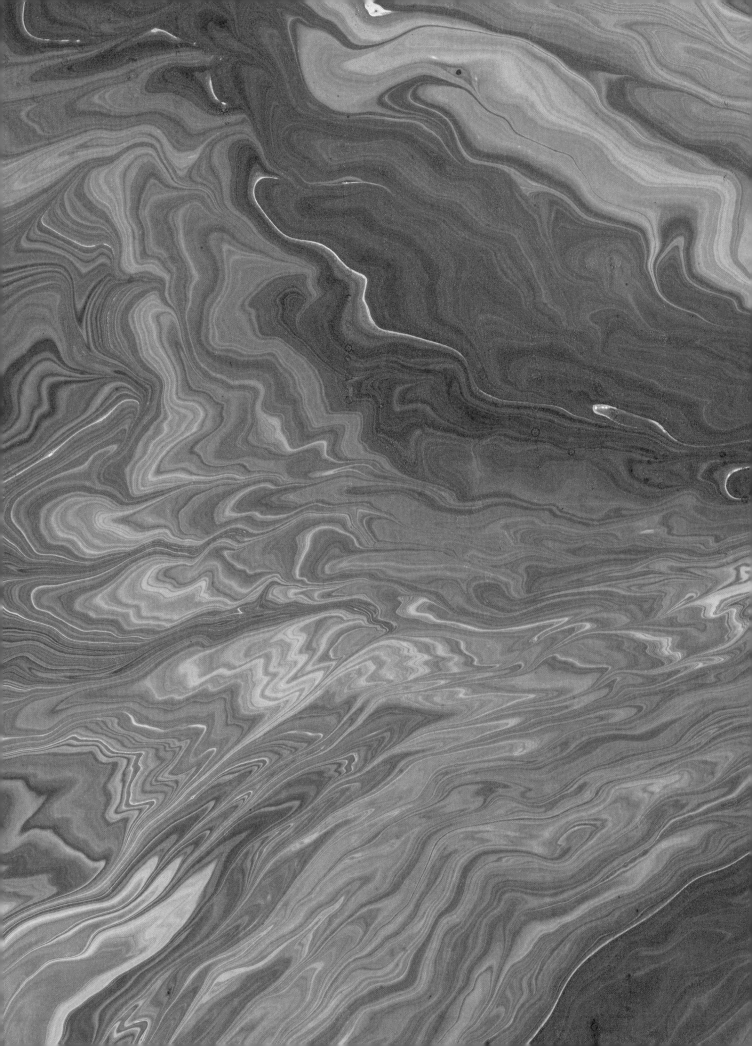